T0286774

CHURCHES OF SHROPSHIRE

DAVID PAUL

AMBERLEY

This edition first published 2022

Amberley Publishing
The Hill, Stroud
Gloucestershire GL5 4EP

www.amberley-books.com

Copyright © David Paul, 2022

The right of David Paul to be identified as the Author
of this work has been asserted in accordance with the
Copyrights, Designs and Patents Act 1988.

British Library Cataloguing in Publication Data.
A catalogue record for this book is available from the British Library.

ISBN 978 1 3981 1053 3 (print)
ISBN 978 1 3981 1054 0 (ebook)

Typesetting by SJmagic DESIGN SERVICES, India.
Printed in Great Britain.

CONTENTS

INTRODUCTION

After walking along and exploring many of the byways in and around Shropshire, it is easy to understand why so many beautiful and ancient churches have been built to complement the rolling and varied countryside of the county. There are more than forty Grade I listed churches in the county, many having national significance. For example, when the king stayed at Acton Burnell in 1283, he held a meeting of parliament there that passed *Statutum de Mercatoribus* (Statute of Acton Burnell). The meeting is historically significant in that it is believed that it was the first occasion where 'commoners' were represented at any parliamentary meeting.

Various styles of architecture are evidenced within the twenty-six Grade I listed churches detailed throughout the text, the earliest dating from the Saxon and Norman periods. Gothic architecture, which had its origins in northwest France, was beginning to replace the old Norman style of church architecture sometime during the twelfth century. The three predominant styles included Early English Gothic, which dates from around 1180 to 1250 and is characterised by pointed arches or lancets. In addition to using pointed arches in wide-span arches, such as the nave arcade, lancet design was used for doors and, more often, stained-glass windows. Characterised by the tracery on the stained-glass windows, Decorated Gothic was fashionable between 1250 and 1350. Design innovations allowed for increasingly elaborate window designs, separated by narrowly spaced parallel mullions. Finally, Perpendicular Gothic dates from 1350 to 1520 and is characterised by a predominance of vertical lines, which is most noticeable in the stone tracery of the windows. This is demonstrated to its best effect in the design of enlarged windows, utilising slimmer stone mullions than was possible in earlier periods, thus giving greater flexibility for stained-glass craftsmen. Also, because of various difficulties which often arose in building during those tumultuous times, many of the churches described incorporate several different architectural styles, indicating that the buildings took many years to evolve and complete. Similarly, it was not unheard of for a church benefactor to have the church rebuilt or substantially modified to conform to contemporary ecclesiastical fashion.

The book does not purport, in any way, to be an academic text, but is aimed at the general reader.

David Paul
26 June 2021

St Laurence's, Ludlow

The parish church of St Laurence was established by the Normans during the latter part of the eleventh century, when the Normans founded the town of Ludlow itself. There are some Norman traces still evident under the south porch, and the church is the largest parish church in Shropshire, often referred to as the 'Cathedral of the Marches', which bears witness to the significance of the town at the time, especially with the turbulence that was experienced in the region of the Welsh Marches.

As Ludlow's population grew, the church had to be enlarged and was completely rebuilt in 1199. As a clear statement of the woollen trade's influence on the prosperity of the town, a number of significant modifications were made to the church in 1433 and again in 1471, when the town's guild of merchants re-modelled the building, erecting many family tombs.

During this period, the tower, nave and chancel were all considerably modified. Following contemporary design, the tower, some 135 feet high, was rebuilt in the Perpendicular style.

Traditionally, the north St John's Chapel was the chapel of the Palmers' Guild, and the depictions in the Palmers' window were inspired by the Ludlow Palmers' pilgrimage to the Holy Land. More appropriately referred to as The Guild of St Mary and St John, it was one of the more prominent guilds, with membership being restricted to guildsmen who had made a pilgrimage to Jerusalem. By way of validating their journey, pilgrims often returned bearing a palm leaf. In order to embark upon such an onerous journey, it was an unwritten pre-requisite that merchants were extremely wealthy, and it was members of this guild who

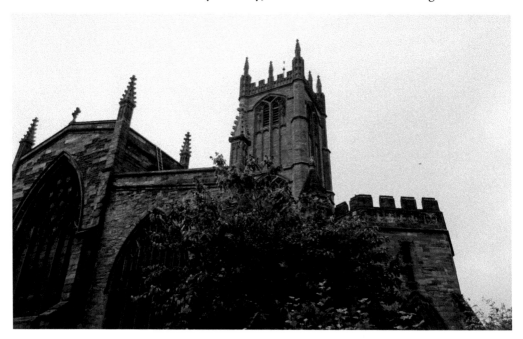

St Laurence's Church, Ludlow.

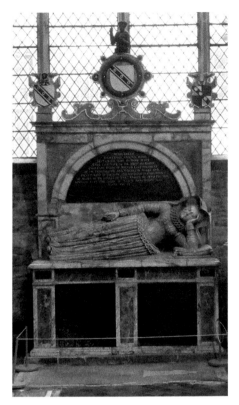 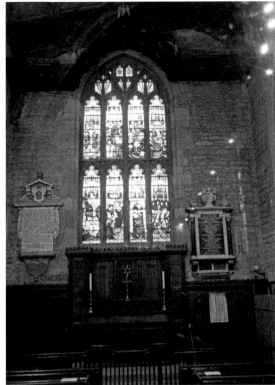

Above left: The chest tomb memorial to Dame Mary Eure in St Catherine's Chapel.

Above right: The Palmer's window in St John's Chapel.

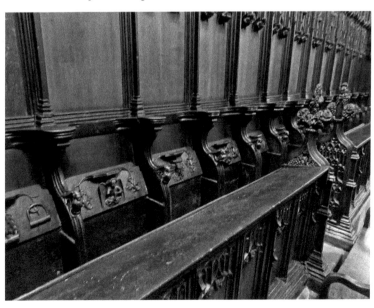

Chancel misericords.

commissioned the cruciform church to be built, together with its unusual octagonal porch. The Palmers' Guild commissioned the north chapel and endowed three chaplains who were charged with praying, every day, for the living, the dead and the honour of the Cross.

The original stained-glass windows, which still adorn the chapel, depict the Palmers on the road to Jerusalem. There is also a depiction of the Annunciation set into the north wall of the chapel.

The Lady Chapel is opposite the Palmers' Chapel and displays a number of dedication boards and biblical texts. The chapel also has a restored stained-glass window that depicts the Tree of Jesse.

In 1832, the east window of the chancel, depicting the martyrdom of Saint Laurence, was restored. However, further major restoration and re-ordering was carried out between 1859 and 1861, when there were glazing repairs, roof refurbishments, and the floors and seating updated, with further work being carried out between 1870 and 1909, which included remedial work on the tower. The church roof was completely refurbished between 1953 and 1959.

The medieval choir stalls in the chancel display exquisitely and intricately carved misericords or 'mercy-seats', as they were often called. The misericords were designed to help support clergy whilst standing during the long religious offices. Sixteen of them date from around 1425, whereas the other twelve are of a later date. Much of the oak – some one hundred planks – from which they are made was bought by the Palmers' Guild from Bristol.

The misericords have a wide range of themes, as the carvers were often given free rein when it came to subject matter, and many portray witches and mermaids, wrestlers, and the Green Man.

The stalls doubled in number in 1447, after the chancel had been lengthened. Then, in the nineteenth century, the stalls were restored under the direction of George Gilbert Scott, and the canopies were replaced after having been removed at the time of the Reformation.

The stained-glass window depicts six of the Ten Commandments being broken. A great deal of refurbishment and conservation work was carried out in 2008, which included new heating and lighting throughout the church.

Originally located in a gallery beneath the tower, the John Snetzler organ is now to be found in the north transept. Costing £1,000 at the time of installation in 1764, the organ was gifted to the church by Henry Arthur Herbert, 1st Earl of Powis. During the nineteenth century, the London organ company Gray and Davison restored and enlarged the organ. Further restoration was carried out in the 1980s by the pipe organ builders Nicholson & Co Ltd of Worcester, and again in 2006, when improvements were made to the console. Further work on the organ has included new keys being fitted.

The Parvis Room, which sits above the porch on the first floor, houses a small history museum. In the porch itself there are six bronze plaques and other tokens commemorating townsmen who died in the service of their country during various conflicts, including the First World War, the Second World War and the Korean War.

The bells, which were increased in number to ten in 2009 by the Whitechapel Bell Foundry, ring tunes four times a day, each day of the week. The ancient font that

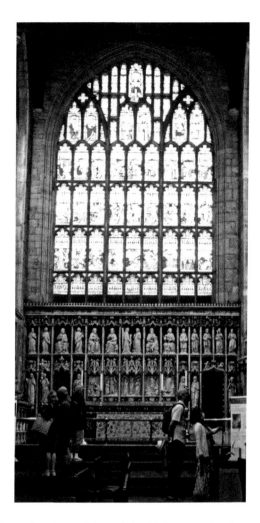

Chancel, east window.

adorns the church is thought to date from the time of the original Norman site. Set into the north wall of the church, near to the west door, is a stone memorial tablet to the poet A. E. Housman. The ashes of the poet are buried in the church grounds.

Location: **SY8 1AN**

ST MARY THE VIRGIN, CLEOBURY MORTIMER

Although there is no compelling evidence to support the assertion, it is possible that the founding of St Mary the Virgin dates to pre-Norman times, the time of Queen Edith of Wessex. It is, however, known that there was a priest in Cleobury Mortimer when the Domesday Book was written. The present church dates from the twelfth century, and the oldest part of the church remaining is the west tower.

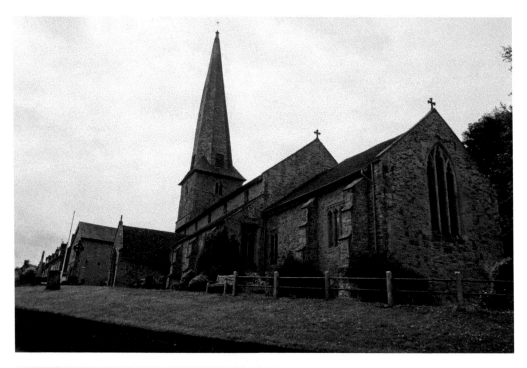

Above: Parish church of St Mary the Virgin, Cleobury Mortimer.

Left: Hagioscope, also known as a 'Leper's squint', set into the north wall of the chancel.

The chancel, south aisle and five-bay nave were added during the early part of the thirteenth century, with the chantry chapel and porch being added later in that century. The roof over the south porch is of national importance, having been recorded as being one of the oldest in the county. The north aisle was built in the fourteenth century. The side chapel, also known as St Nicholas's Chapel, was commissioned by Roger Mortimer, 3rd Baron Mortimer and 1st Earl of March, who, many years later, was accused of several crimes, including assuming royal power. Mortimer was hanged at Tyburn on 29 November 1330.

Originally, the church had a stone altar but, in 1553, it was decreed that all stone altars should be destroyed and replaced with 'a decent wooden table'. Similar in many respects to the Chesterfield Parish Church, the church of St Mary the Virgin at Cleobury Mortimer is probably best known for its crooked spire. The tower itself is in four notable parts, the lower two dating from the twelfth century, and the upper two stages built during the following century. The main reason for the twist and lean can be attributed to the fact that the spire was placed on the tower without any tying or flashing and, over a period, weathering caused the timbers to rot and the soft building stone to crumble. The twist occurred as a result of the timbers drying out. Some remedial work was carried out in 1994, when it became necessary to reinforce the integral strength between the spire and the tower. The spire was also re-shingled at this time.

The tower has a ring of six bells, the first five being cast in 1757 by Adam Rudhall of Gloucester, and the sixth bell being cast in Croydon by Gillett and Johnston. The clock face is on the south side of the tower and was erected in 1772 by Mr George Donisthorpe of Birmingham.

There is a hagioscope or, as it is more commonly called, a 'leper's squint', set into the north wall of the chancel. The purpose of this was to enable people in the churchyard – for that was where it was originally – to see the sacred elements being blessed at the altar. People viewing through the 'squint' avoided being fined for not being present at Mass. A plaque depicting the Last Supper is near to same location.

It became apparent during the eighteenth century that the church's south wall was leaning outwards. The County Surveyor for Shropshire, Thomas Telford, commissioned brick buttresses to be built to shore up the wall. The brick buttresses were later replaced with stone ones.

During 1874 and 1875, Sir George Gilbert Scott was commissioned by the church to carry out significant restorations and refurbishments, which included building a decorated arch into the vestry (now serving as the organ chamber) and inserting half arches to span the aisle. Scott was also commissioned to replace many of the windows, replace the box pews, remove the three-tiered pulpit, and remove the medieval paintings from the walls. Much of the costs of the renovation were paid for by the vicar at the time, Prebendary Baldwyn Childe. During Scott's restoration, the tower arch on the inside of the church was strengthened, necessary because the weight of the tower above was causing damage.

When the nineteenth-century restoration was completed, the vicar had the east window installed. The window, designed by Harry Burrow, depicts episodes from the Middle English allegorical narrative poem 'The Vision of Piers the Plowman' by the poet William Langland, who, it is believed, was born near to Cleobury.

 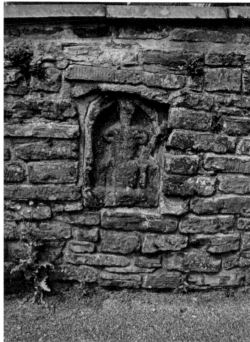

Above left: The east window, designed by Harry Burrow.

Above right: Sheela-na-gig inset into boundary wall.

Many of the stained-glass windows at St Mary's were manufactured and installed by James Powell of the Whitefriars Glass Company. One of his windows in the south wall of the chancel, which was designed by Thomas Willement, depicts the Good Shepherd. Similarly, Whitefriars installed the glass in the south aisle, which was designed by Henry Holiday and depicts Saint Paul and Saint Timothy.

The two-manual pipe organ was made and installed by Nicholson of Worcester in 1884. The organ was rebuilt in 1904 before further improvements were made by the organ builder Lawrence J. Snell in the 1970s.

There are monuments on the north wall in the north chapel commemorating men who died in in the First and Second World Wars. The memorial was designed by the then vicar of the parish. Another monument commemorates Captain William Henry Trow of the King's Shropshire Light Infantry. Captain Trow was killed in action at Kroonstad in South Africa during the Boer War in 1900.

When Church Street was widened in the nineteenth century, the wall to the south-west of the churchyard was largely rebuilt. There is a thirteenth-century Sheela-na-gig set into the wall. There is also a sundial in the churchyard, which was formerly a cross. The medieval shaft is set in a hexagonal socket stone.

In 2004, storm damage necessitated the nave roof being retiled and some timbers being replaced. There was further repair work carried out in 2006, when rotting timbers in the south porch were replaced, some of the stonework was restored

and the porch re-tiled. The electrical system, including the church lighting, was upgraded in 2012. More recently, in 2019, a new system of underfloor heating was installed.

Location: **DY14 8BX**

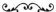

ST MARY'S CHURCH, BURFORD

There has been a church on this site at Burford since before the writing of the Domesday Book.

The chancel of St Mary's dates from the twelfth century and contains some Norman remains. The plan of the church includes a chancel, a nave, a south porch and a west tower. There are many different styles of architecture featured in the church's design. For instance, the chancel has many Norman characteristics,

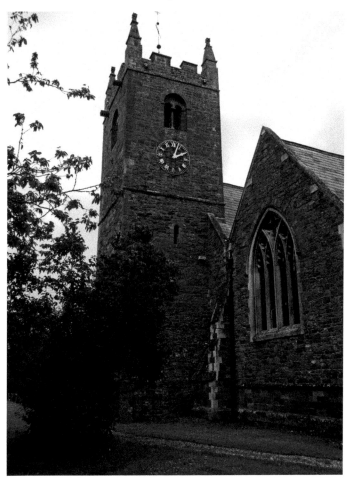

St Mary's Church tower, with south-facing clock.

East window.

whereas the nave is of the Decorated style of architecture, and the tower follows the Perpendicular school of architecture. The font is octagonal and is of the Perpendicular style; there is a medieval stoup by the south door and a carving of the Virgin on the brass lectern. In or around 1860, a north vestry was added, and then, towards the end of the nineteenth century, the Hon. Georgina Rushout commissioned the noted English architect Sir Aston Webb to completely restore the church in honour of the owner on whose land the church stood, Lord Northwick of Burford. Amongst other changes, the tower was completely rebuilt, much of the tracery was replaced in the windows, and buttresses were added to the nave and chancel. The chancel arch and roof were also rebuilt.

Much of the stained glass, which dates from the late nineteenth century and early twentieth century, is from the London-based English stained glassmakers of James Powell and Sons, whose workshops were particularly noted for their Gothic Revivalist glass. Many of the monuments in the church are to members of the Cornwall family and the Rushout family.

There is a medieval churchyard cross to the south of the church, with the original shaft being set on four octagonal steps. In 1867, the upper part was restored and now has carvings of both the Crucifixion and the Nativity. The churchyard also

St Mary's intricately carved pulpit.

Priest's door.

has the war grave of a soldier from the King's Shropshire Light Infantry who fell in the First World War. The preaching cross was re-dedicated in 2010.

Location: **WR15 8HG**

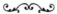

HOLY TRINITY, HOLDGATE

Before Ludlow was established, the parish of Holdgate was the focus of power in south Shropshire. Records show that Holdgate had a church and a priest as early as 1086, while the founding of the church was posthumously accredited to Helgot. A new building, believed to be built on the site of the earlier church, was consecrated by Geoffrey of Clee, Bishop of Hereford, who was the uncle of Helgot's son, Herbert. At that time, the church was called 'Ecclesia de Castello', the Castle Church, as it appears to have been an integral part of the castle. The new Holy Trinity Church was consecrated between 1115 and 1119. Then, sometime before 1121, Herbert donated the church to Shrewsbury Abbey, although Warin, the clerk who held it in the 1120s, retained a life interest.

During the fourteenth and early fifteenth centuries, the rectors tended to be pluralists coming from outside of Shropshire. One rector, Roger of Ottery, who was rector from 1364 to 1387, suggested that the benefice didn't require a resident incumbent.

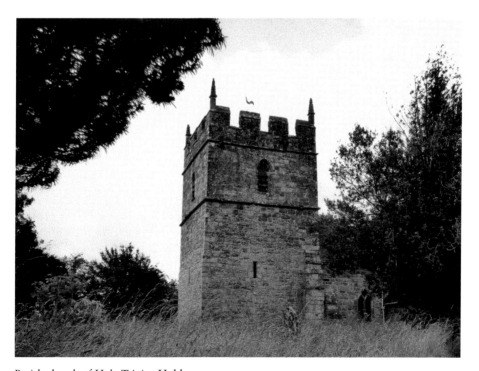

Parish church of Holy Trinity, Holdgate.

The new chancel arch, which was added during the 1894–95 restoration.

Holy Trinity has a chancel, a nave and a south porch. Built from coursed sandstone rubble with tiled roofs, the church also has a west tower. There are lancet windows on three sides of the lower stage of the two-stage tower. The lower part of the tower dates from the thirteenth century, although it was only towards the end of the fourteenth century that the embattled upper stage of the tower, which follows the Perpendicular style of architecture, was added, with this stage being subsequently rebuilt in the seventeenth century. The upper stage has a number of bell openings, and there is a battlement parapet with corner pinnacles on the summit.

Further restoration work was carried out on the upper stage of tower between 1894 and 1895. The chancel, which is slightly lower and narrower than the nave, can be assumed to date from the twelfth and thirteenth centuries, as can be verified from the Sheela-na-gig that features on the outside of the south wall. During the latter part of the thirteenth century and the early part of the fourteenth century, some windows were inserted: two on the south of the chancel and one on the north. New windows were also inserted on each side of the nave. Most of the windows in Holy Trinity are of the Early English style, while the east window is attributed to the stained-glass designer Herbert William Bryans and was installed in 1904.

In 1922, a carved wooden altar was installed and later, in 1930, stained glass was added in the chancel's east and north lancets. Sometime during the

The ancient box pews were retained during the 1854–55 refurbishment.

seventeenth century, a communion rail was placed around three sides of the table and a chair with the inscription 'IH' placed in the chancel. The nave also dates from the twelfth century and has a Norman round-arched doorway in the south wall. Carved doors were added to some of the benches in the nave and a low box pew was made on each side. It would appear that the church singers and musicians led the worship from the rear bench on the north side of the nave, as there is no evidence that there was ever a west gallery.

Dating from 1753 and hanging on the north wall of the nave is the royal arms. In 1793, the west end of the nave was partitioned to create a schoolroom. The church has an ornamented Norman chalice font, which follows that of the twelfth-century Herefordshire School of Carving.

There is a number of brasses dating from the seventeenth and eighteenth centuries. There is also a chest tomb to the south of the nave that dates from the early nineteenth century. Holy Trinity has a ring of three bells, two of which, dated 1657 and 1666, were cast by John Martin at the Worcester Foundry. The third bell, cast in 1754, is from Rudhall's of Gloucester. During 1854 and 1855, under the direction of Mr Davies, the church was re-pewed, although the ancient pews in the nave remained and were re-furbished. Between the years 1894 and 1895, further restoration work was carried out under the direction of the English church architect James Piers St Aubyn and his pupil Henry Wadling. The work

included inserting a chancel arch, renewing some of the windows, replacing roofing, removing the partition in the nave and building a new porch.

The remains of a medieval cross can be seen in the churchyard, and there is a sundial fixed on the broken end of the shaft.

Location: **TF13 6LW**

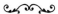

ST LAURENCE'S, CHURCH STRETTON

St Laurence's Parish Church in Church Stretton, sometimes spelt St Lawrence, is in the diocese of Hereford. Although it has been established that the nave was built in the twelfth century, it was not until the following century that the transepts were added. The upper stages of the tower and the chancel were completed in the fifteenth century, and the south vestry was built in 1831.

The church has a traditional cruciform plan, consisting of a nave with two Norman doorways, a chancel and north and south transepts, and a three-stage tower at the crossing. In the main the church, it follows the Early English style of architecture, although the nave is Norman in style, and the upper stage of the tower follows the Perpendicular style. There is an embattled parapet at the summit of the tower with corner finials, while there is a carved figure of Saint Laurence at the southeast angle of the tower. The tracery in the transept's windows and the west window is Decorated in style, whilst the tracery in the east window is Perpendicular in style. The inside roofs of the church are all medieval, and the altar reredos was made in the early part of the nineteenth century from reused seventeenth-century panelling. The octagonal font also follows the Perpendicular style of architecture.

The Shrewsbury architect Samuel Pountney Smith worked on the church's restoration between 1867 and 1868, adding extensions to the transepts, with the north extension being enclosed by a glass partition to form the Emmaus Chapel. Pountney Smith also designed the stone pulpit, which dates from 1880. Further restorations were completed in 1882 and again in 1932.

In 1968, a disastrous fire at The Hotel in Church Stretton killed twins Alistair and Jonathan Goulder and their elder brother Korwin. A memorial dedicated to the brothers was erected in the ceiling of the tower by their parents. The sculpture, *The Symbol of St. Laurence*, by John Stephen Skelton can be seen by looking up to the roof of the crossing. Two members of the hotel's staff also died in the fire, and they are commemorated by means of a memorial plaque that was dedicated by the Bishop of Ludlow in May 2013.

Many of the windows in the north and south sides of the chancel have a number of Flemish roundels – there is also medieval glass in some of the windows. An early window by Burlison and Grylls features in the nave, and the east window was manufactured by the local company Betton and Evans. There is a memorial window to Lord Leighton of Stretton, former President of the Royal Academy, in the west side of the south transept. Another memorial window commemorates the locally born children's writer Sarah Smith, who wrote under the pen name of Hesba Stretton.

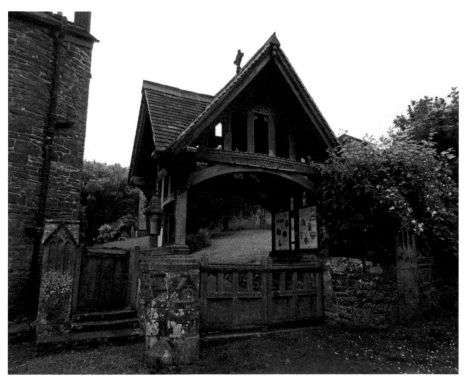

Ancient lychgate leading to St Laurence's Church.

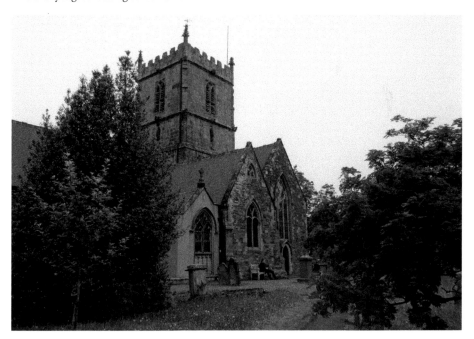

St Laurence's Church, Church Stretton.

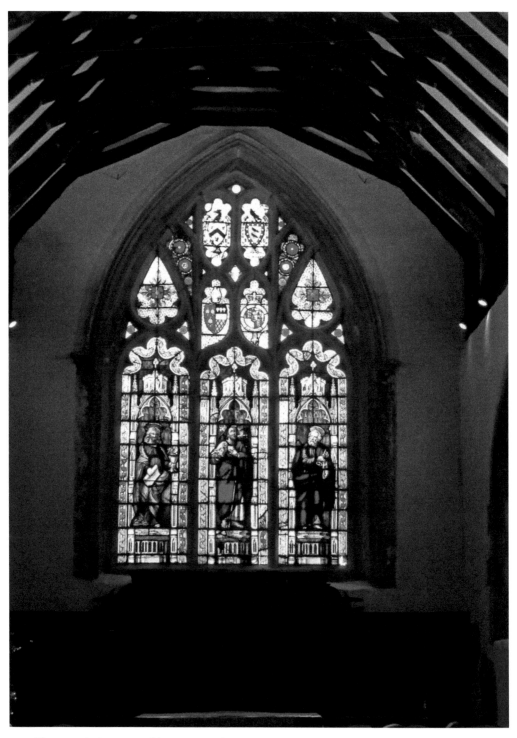

The east window, created by Betton and Evans.

The Symbol of Saint Laurence by John Stephen Skelton.

Perhaps her most famous book was *Jessica's First Prayer*, which, by 1900, had sold well over a million copies, even outselling *Alice's Adventures in Wonderland*.

The church has a ring of eight bells; the first four were cast in 1711 by Abraham Rudhall I of Gloucester. The other four bells were cast in 1890 at the foundry of John Taylor & Co of Loughborough. In 1883, the organ builders Nicholson & Co of Worcester made and installed a two-manual pipe organ. In 1987, the organ was restored by the same company. A new heating system, lighting system and sound system were installed in 2010.

Location: **SY6 6DQ**

St Mary's, Hopesay

The church of St Mary, Hopesay is approached through a lychgate that was built in 1892. The church itself dates from the beginning of the thirteenth century, with a late fifteenth-century moulded, arch-braced collar beam roof. St Mary's has a traditional structure plan, consisting of a chancel, nave, a windowless south porch, a north

organ chamber and a strong western tower dating from the seventeenth century. The tower bears more than a passing resemblance to the squat towers of St George's, Clun, and St Peter's, More, which are also capped by pyramid roofs. The tower has a ring of four bells, while the original porch dates from the seventeenth century. There is a gallery at the west end, which has a cast-iron column to the north end but continues to retain a seventeenth-century wooden board, upon which is written 'BUILTE AT THE CHARGE OF EDWARD BLOOME ESQ ANNO DNI 1631'.

Towards the end of the nineteenth century, the chancel was restored by the Gothic Revival architect William Butterfield. Some further changes were made under the direction of a local architect, A E Lloyd Oswell in 1897. There are two fonts in the church, the earlier one, dating from the Norman period, stands inside the south door. The other is a Victorian octagonal font.

The porch, dating from the seventeenth century.

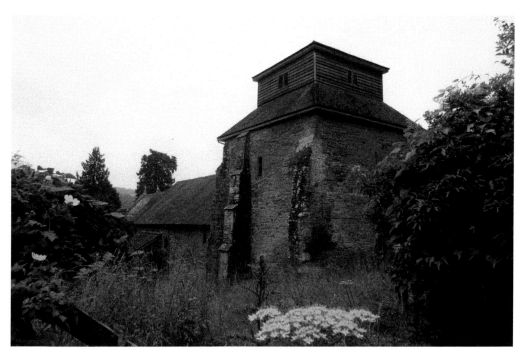

St Mary's Church, Hopesay.

The west gallery is supported by cast-iron columns. The canted chancel ceiling
has painting in the east bay. The nineteenth-century pews and choir stalls were
carved from panelling from seventeenth-century box pews. On the north wall of
the nave is an early twentieth-century stained-glass window created by the English
painter and designer Mary Jane Newill, whereas on the south wall there is some
fourteenth-century glass in one of the windows, and another window on the same
wall is by the renowned Victorian stained-glass designer Charles Eamer Kempe.
The Crucifixion is depicted in the east window which was designed by Joseph Bell.
The window, dating from 1858, commemorates the life of Charles Henry Beddoes
who died in 1856. The two-manual pipe organ was made and installed by the
Huddersfield-based organ builders Conacher and Co. and, in 1985, was restored
by the organ builders Nicholson & Co. of Worcester.

There is a round-headed priest's door on the south wall of the chancel, together
with two lancets and a two-light window. There are also lancet windows in the
organ chamber. The wooden pulpit is dated 1897, and the altar and reredos date
from the early twentieth century. On the west tie beam of the roof there is a framed
wooden board on which is painted 'Tho: Perks Gave to this Parish Forty Pounds'.
In 1840, when John Disley made the wrought-iron gates to the porch, they were
probably considered to be an expensive item at £4 12s.

Location: **SY7 8HA**

St John the Baptist, Hughley

Sometime during the 1170s, the chapel of Lee (Hughley) and its patronage were granted to Thomas of Lee, Lord of the Manor, by the Prior of Wenlock, Peter de Leia (Lehe).

Initially, the chapel might have been a dependency of Cound Church, but later it was absorbed into the parish of Holy Trinity, Much Wenlock. The church was rebuilt during the thirteenth and fourteenth centuries, becoming a parish church during the sixteenth century.

With the help of the Incorporated Church Building Society, the church was refurbished in 1842. The work included the nave being re-pewed, with many of the new pews being 'free'. There was a major restoration during the 1870s, when the renowned ecclesiastical architect Richard Norman Shaw created the trussed rafter roof and restored the west window. There was more re-pewing in 1900 when, once again, there was further restoration in the church, which also included re-flooring the nave and repairing the east window jambs. Then, from 1943 until 1965, Hughley was served from Frodesley. Later, from 1965 until 1973, the parish was linked with Harley and subsequent to that with Much Wenlock. The benefice of Hughley with Church Preen was merged with the Wenlock Team Ministry in 1981.

Church records show that, from the early part of the eighteenth century until 1777, there were two services held every Sunday, one having a sermon – with Holy Communion only celebrated at Christmas, Easter, and Michaelmas. Towards the latter part of the eighteenth century, Holy Communion was celebrated four times a year, but congregations were small, with normally fewer than twenty communicants.

The lancet windows in the north wall of the nave date from the thirteenth century. The north and south nave doorways, the chancel floor tiles, and all of the other windows date from the fourteenth century. The east window has fragments of late medieval glass, and the porch, having continuous lights with fourteenth-century tracery, has undergone several repairs over the centuries. Intercepting a nave window on the south and a chancel window on the north is the carved-oak, medieval rood screen which, it is believed, was taken from the nearby Buildwas Abbey at the time of the Dissolution of the Monasteries. Dating in part from both Norman times and the Decorated period of the fourteenth century is a pillar piscina, which is attached to the south wall.

In 1552, the church had two bells, a chalice and paten of silver. Early in the eighteenth century, the church received new plate and four new bells, which were cast by the family firm of bell founders, Rudhall of Gloucester.

The brick and timber bell tower dates from 1701, with the octagonal clock on the bell turret being presented in 1893 by Viscount Newport, the 3rd Earl of Bradford and nominated as the church's patron after his horse, Sir Hugo, won the 1892 Epsom Derby at a starting price of 40/1. (Even then, the winner's prize money amounted to £5,500.) When George Bridgeman, the 4th Earl of Bradford, died in 1915, the chancel south window was glazed in his memory.

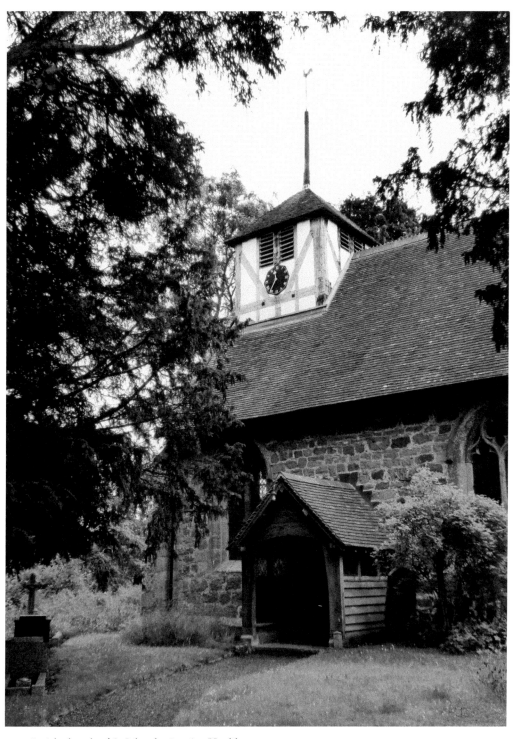

Parish church of St John the Baptist, Hughley.

The carved oak medieval rood screen.

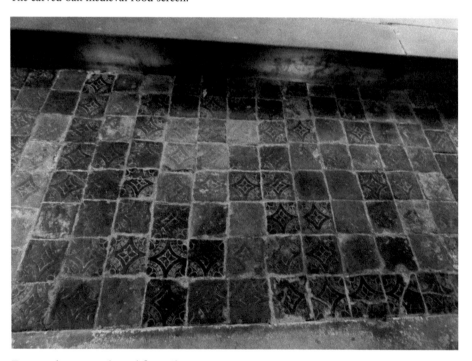

Fourteenth-century chancel floor tiles.

The 8-foot-long Peter's Pence chest.

There is an 8-foot-long Peter's Pence chest at the western end of the church. Peter's Pence were donations made directly to the Holy See of the Catholic Church, although some people viewed it more like a tax. The practice started in Saxon England but was formally discontinued at the time of the Reformation.

One of the poems in Housman's collection *A Shropshire Lad* has the title 'The Vane on Hughley Steeple', although the church of St John the Baptist has never had a steeple as such. Traditionally, there is a parish wake that is held on the first Sunday after the decollation of Saint John the Baptist, the feast day being observed on 29 August.

Location: **SY5 6NT**

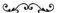

HOLY TRINITY, MUCH WENLOCK

Saint Milburga (alternatively Mildburh or Milburgh) was the daughter of Merewalh, the King of Mercia. She founded a religious community here sometime in the seventh century which, after being established for some years, eventually

became known as Wenlock Priory. The foundation was known as a 'double house', as it had separate accommodation for monks and nuns. Then, in or around 1101, the bones of the saint herself were discovered in the church. As a result of this discovery, it was considered that Holy Trinity must have originally been the women's church in the 'double monastery'. During this time, Holy Trinity had been rebuilt to accommodate the parishioners from the embryonic town that was developing around the monastery.

It was the Cluniac Reforms of Wenlock Priory who, in the middle of the twelfth century, built the present church of Holy Trinity. There are characteristic Norman arches and pillars in both the chancel and nave; the Norman carvings on the west tower arch can still be seen, although partly obliterated by the west tower, which was built at a later date. When the priory closed in 1540, the advowson passed to the Crown. It was then sold to Henry Bromley and then to a series of Lords of the Manor.

Both the chancel and nave date from the Norman period, with the west tower being added later on. The chancel has a plaster barrel ceiling, with the north aisle having a well-preserved hammerbeam roof. The Norman font stands at the east end of the south aisle, and although lost for many years, it was returned to the church when it was re-discovered in the Victorian age. The south chapel and south

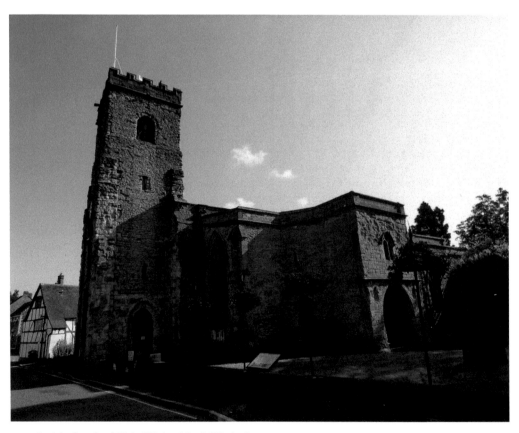

Parish church of Holy Trinity, Much Wenlock.

The Victorian box pews.

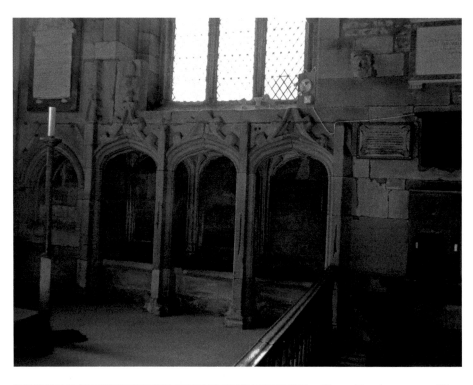

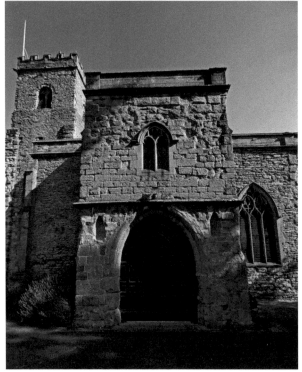

Above: The three-seat sedilia set into the south wall of the sanctuary.

Left: The fourteenth-century parvise above the south porch.

aisle were added towards the end of the twelfth century, with further additions in the thirteenth century. The floors of both the aisle and nave are laid with red and black tiles, and the floor of the chancel is made, mainly, from re-used grave slabs. There is a fourteenth-century parvise, a small chamber, which is set above the south porch. The parish priest was said to have used this chamber as his living quarters. A three-seat sedilia is set into the south wall of the sanctuary, and the nearby east window contains some fragments of stained glass, which are dated as early as the fifteenth century. The church pews are Victorian, although there is evidence that some eighteenth-century carved panels have been reused. The pulpit is Jacobean.

The Shrewsbury architect Samuel Pountney Smith made alterations to both the south aisle and south chapel in 1843 and 1866 respectively. The Father of Arts and Crafts architecture, Philip Speakman Webb, then had further alterations made to the chapel in 1877. There is a plaque to novelist Mary Webb on Church Green.

Location: **TF13 6HR**

ST PETER'S, ADDERLEY

Although there has been a church on this site since the thirteenth century, the present church of St Peter, Adderley, was completely rebuilt in 1801 to the designs of Richard Baker – the only known ecclesiastical work of this architect. Built

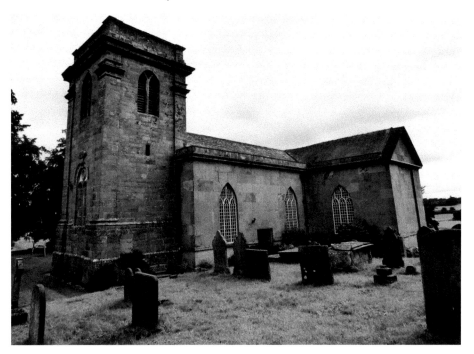

Church of St Peter, Adderley.

mainly from yellow sandstone, with red sandstone used for the tower, the church has a traditional cruciform plan, with a single-bay chancel and transepts, a three-bay nave and a western tower with pinnacles containing a clock and three bells.

The Kilmorey Chapel in the north transept has a battlement parapet with crocketed pinnacles at the corners and was built as a burial chapel for the Needham family, the Viscounts Kilmorey of Shavington. The chapel was built between 1635 and 1636 and is the oldest surviving part of the present church, together with the large, Norman-style font, another one of the few survivors from the thirteenth-century church, containing a Latin inscription that literally translated reads 'Here wickedly the first man enjoyed the apple with his wife'. The carved wooden screen at the entrance to the north transept dates from the earlier part of the seventeenth century.

It is thought that the chancel screen, dating from 1908, is the work of the English ecclesiastical architect Charles Hodgson Fowler. The west tower, built in 1712, is the only other remaining part of the original church. Set on a plinth, the tower is in two parts, with a round-headed west doorway set in the lower part and a two-light louvred bell opening in the upper part. The cast-iron window frames and tracery were manufactured in one of the foundries at Coalbrookdale and follow the Perpendicular style of architecture.

There are several memorials to members of the Needham family throughout the church, including three stained-glass heraldic panels in the north transept, depicting twelve of the Needham family coats of arms.

Eighteenth-century red-sandstone sundial.

Four-step sandstone mounting block.

An interesting brass shows Sir Robert Needham, his wife Agnes and their nine children.

The church has a hexagonal wooden pulpit which dates from the early nineteenth century, and there are tablets above the south doorway inscribed with the Lord's Prayer and the Creed.

There is an eighteenth-century red sandstone sundial in the churchyard and a four-step sandstone mounting block, which also dates from the same period. The parish church of St Peter's, Adderley is unusual in that it has a dual function: the nave and tower continue to form an integral part of the parish church, whilst the chancel and transepts fall under the care of The Churches Conservation Trust.

Location: **TF9 3TD**

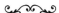

ALL SAINTS, CLAVERLEY

Outside of the north-eastern corner of the church of All Saints, Claverley there is a yew tree that is certificated as being over 2,500 years old, giving rise to the belief that, in all probability, because yew trees were commonly planted in sacred places, the site was being used as a place of worship even before Christianity came to Britain. The original foundations, situated directly under the chancel, are thought to be Roman in origin.

The wooden church, which was built early in the seventh century, stood on an earlier foundation. Roger de Montgomerie, 1st Earl of Shrewsbury, founded the

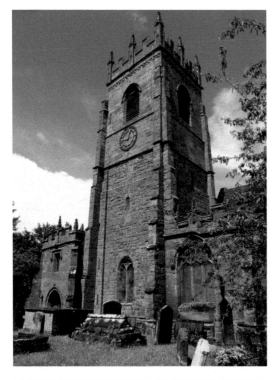

Parish church of All Saints, Claverley.

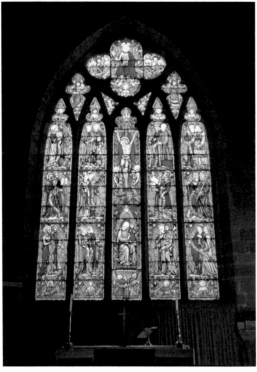

The five-light east window by Frederick Preedy.

present church in the eleventh century, during the reign of Henry I. The church was established as a collegiate chapel of the royal castle at Bridgnorth. The church's west and north walls are from the Norman period and form the oldest parts of the church. Built in red sandstone, the church has north and south aisles, a nave with a clerestory, and a three-bay chancel that has two bay chapels to the north and south. There is a four-stage tower in the centre of the south side, with the upper embattled stages being added towards the end of the fifteenth century. Also, at this time, the north chapel was added. Some significant restoration was carried out in 1902 when the upper two stages of the tower were rebuilt to their original design by the architect William Wood Bethell.

The chancel, which follows the Decorated style of architecture, has a five-light east window, whereas the south chapel is Perpendicular in style. The chancel was extended and rebuilt during the fourteenth century and this, coupled with the fact that there are many monuments to leading families in the locality, indicates that the church was one of some significance. The north chapel has elements of both Decorated and Perpendicular styles. The west window of the nave is from the Decorated period, as are the windows inside of the north aisle. Examples of Perpendicular windows can be seen at the west end of the north aisle, in the south aisle and in the clerestory.

With the exception of the eastern-most arch, the Norman north arcade dates from the early twelfth century. The round arches, which are carried on circular piers, have circular capitals. Dating from the middle of the thirteenth century,

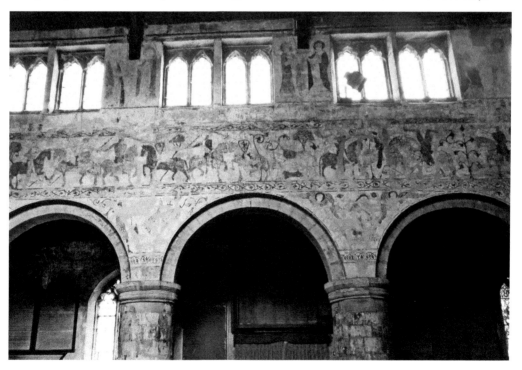

North wall fresco.

the two-bay arcade to the west of the tower is carried on octagonal piers. Both the two arches leading into the north chapel and the chancel arch follow the Decorated style of architecture, whereas the nave roof and the arch into the south chapel are of the Perpendicular style. The chancel has a hammerbeam roof, considered to be 'the most spectacular endeavour of the English medieval carpenter'.

There are two fonts in the church, one believed to date from the Saxon period. The main font is tub-like in appearance. A more recent addition to the fabric of the church is an altar rail adhering to the style of the Arts and Crafts movement, designed and made *c.* 1912 by F. Waldo Guy, the brother of the church's vicar at that time. The late twelfth-century wall painting, situated directly above the arcade of the north wall of the nave, is of a similar form to the Bayeux Tapestry frieze and depicts fifteen knights in combat. This and other wall paintings were only discovered during church restoration work being carried out in 1902. Also discovered beneath the nave during the restoration was a raft foundation, together with human and animal remains. The burials and the raft foundation were in a north-south alignment, suggesting that they dated from the Roman period. There is also a painting which depicts the martyrdom of Saint Margaret of Antioch.

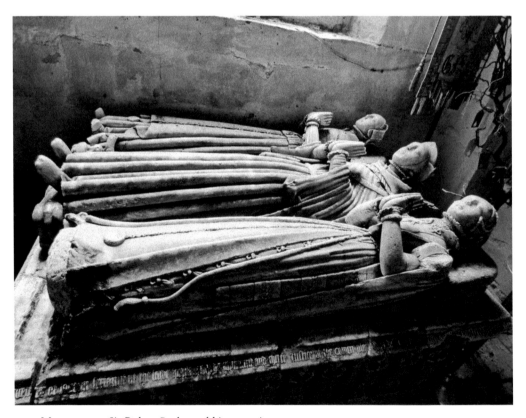

Monument to Sir Robert Broke and his two wives.

The Saxon font at
Claverley.

Dating from 1858, the stained glass in the east window is by the architect
and glass painter Frederick Preedy and is a depiction of the Te Deum. Based on
Raphael's *Transfiguration*, the east window in the south chapel, which dates from
1849, is by David Evans. There are several other stained-glass windows of note
in the church, including windows by John Hardman, William George Taylor and
Archibald John Davies of the Bromsgrove School. There are several monuments
of note in the church, including one to Richard Spicer (*d.* 1448) and his wife.
There is an alabaster monument in the north chapel dedicated to Sir Robert Broke
(*d.* 1558), Speaker of the House of Commons in 1554, and his two wives: Anne
Waring his first wife, and Dorothy Gatacre his second wife, daughter of William
Gatacre.

In the south chapel there are monuments to William Gatacre (*d.* 1577) and to
Francis Gatacre (*d.* 1599).

Between carved arches in the west end of the church there is a parish war memorial, remembering men of the parish who died in both the First and Second World Wars. Joseph William Walker made and installed the two-manual pipe organ in 1906. The organ was rebuilt in 1964 by W. Hawkins. The church has a ring of eight bells, the oldest being cast by Abraham Rudhall, the elder, in 1703. A second bell was added by his grandson Thomas Rudhall in 1769. Other bells were cast by John Taylor & Co., with the last four bells being cast in 1929 by Gillett & Johnston. There is a fourteenth-century cross standing on a plinth at the entrance to the churchyard, whereas the church's brick lychgate dates from the nineteenth century.

Location: **WV5 7DT**

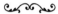

ST MARY'S, ACTON BURNELL

The Domesday survey makes no reference to there being a church at Acton Burnell, but it is thought that there was a chapel here as early as the twelfth century. The present church dates from the middle of the thirteenth century; it is also recorded that there was an anchorite cell here as early as 1280.

It could be said that Robert Burnell had a meteoric rise to fame. Burnell was the son of a local landowner and, after being priested, became tutor, secretary, and chaplain to Henry III's son Prince Edward. Burnell later became Bishop of Bath and Wells, and the King's Lord Treasurer and Lord Chancellor when the prince acceded to the throne and became Edward I in 1272.

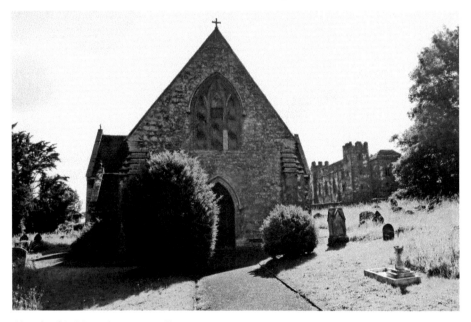

Church of St Mary, Acton Burnell.

Looking towards the east window.

The whole area was rebuilt by Bishop Burnell, and this included the complete rebuilding of the church that occupied this location. Because of his wealth and his position as bishop, Burnell was able to employ the best masons and craftsmen when he built the Early English church of St Mary. The church was constructed between 1275 and 1280.

When the king stayed at Acton in 1283, he held a meeting of parliament which passed *Statutum de Mercatoribus*, known as the Statute of Acton Burnell. Tradition dictates that, during the meeting, the lords sat in a hall of the castle,

whilst the commoners sat in the adjacent tithe barn. The parliament was of constitutional significance as, it is believed, it was the first time that commoners had been represented at any such parliamentary meeting.

The plan of St Mary's follows the typical cruciform pattern. The church building itself is constructed from sandstone and has tiled roofs. There is a five-bay chancel with south chapels and a ten-bay nave with a north porch. The tower, which is in three stages, is located between the chancel and the north transept, and features a pyramidal roof with a weathervane. There are two louvred bell openings in the top stage, quatrefoil openings in the middle stage and a doorway and a lancet window in the bottom stage. There is a small square window, known as a 'hagioscope' or 'squint', low down in the chancel. The 'squint' enabled lepers, who gathered in communities outside of the church, to witness the blessing of the bread and the wine during the Mass. Lepers were not allowed to attend church services, despite there being a fine for anyone else not attending Mass.

There are three notable memorials in the north transept. To the right, there is a memorial to Sir Richard Lee, who died in 1591. Sir Richard is shown together with his wife and twelve children. In the north-east corner, there is a table tomb in memory of Sir Nicholas Burnell, the 1st Lord Burnell, who died in 1382. There is the monument by Nicholas Stone to Sir Humphrey Lee on the west wall. Sir Humphrey, who died in 1632, is portrayed in prayer together with his wife and children. The church also has memorials to members of the Smythe family, one of the leading catholic families who had been Lords of the Manor since 1660.

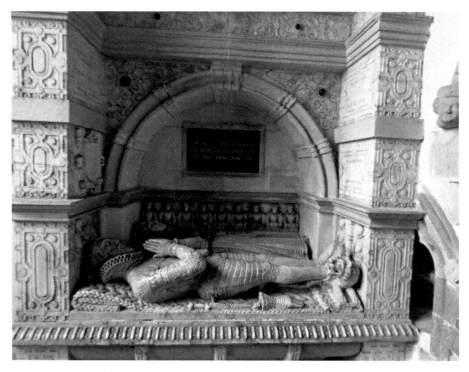

Monument to Sir Richard Lee, together with his wife and children.

Above: The 'Leper's squint'.

Right: Wall monument
to Sir Humphrey Lee and
his wife.

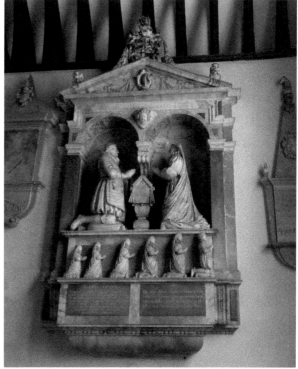

There were no major structural alterations to the church until the 1580s, when roof repairs became necessary. Further structural work was carried out in the 1880s, when between 1887 and 1889, under the direction of the English architect Fairfax Blomfield Wade-Palmer, a new tower was added. There is a stained-glass window, which was inserted as a memorial to Rev William Serjeantson, former rector of the parish for sixty years, from 1862 to 1922. Depicted in the centre light is Saint Mary, with depictions of King Edward I and Bishop Burnell in the side lights.

St Mary's has a ring of four bells, the oldest dating from 1650. The bell founders, James Barwell Ltd, cast the other three in 1912. In 1973, Ward and Shutt built the two-manual pipe organ, which is located in a chamber to the north of the chancel. The sandstone font in the churchyard to the north of the church dates from the fifteenth or sixteenth century, and it is thought to have been moved from a redundant chapel at Acton Pigott.

Location: **SY5 7PE**

ST MARY THE VIRGIN, SHREWSBURY

The medieval Church of St Mary the Virgin stands in the centre of Shrewsbury. The church can be seen from some distance, as it has the third highest spire of any church in England, rising to a height of some sixty-eight metres. Much of the architecture

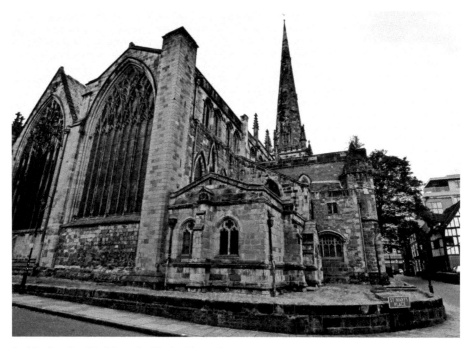

Parish church of St Mary the Virgin, Shrewsbury.

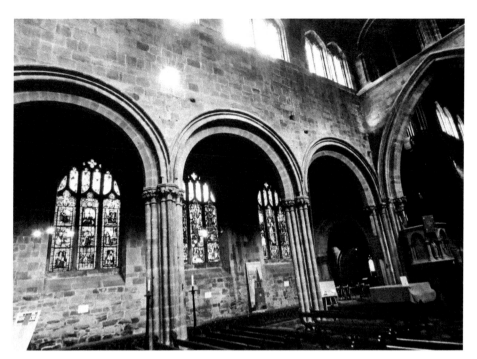

North-side Norman arches.

would suggest that the main body of the church dates from the twelfth century, although many believe that the church was founded as early as the tenth century by King Edgar the Peaceful, and that by the thirteenth century it was served by a dean and nine canons. Over the years, there have been many alterations and additions.

On Sunday 11 February 1894, while a ferocious storm was raging throughout the country, many buildings were destroyed, and there were also many fatalities. There were many theories forwarded when the spire collapsed – one of the more popular views being that God was angry at the thought of a statue of Charles Darwin being erected outside of the nearby Shrewsbury School. It was not until 1897 that the spire was replaced.

The church has a number of remarkable stained-glass windows, many dating from the fourteenth century, including the renowned fourteenth-century Tree of Jesse east window, which also has scenes from the life of Saint Bernard and depictions of Old Testament kings and prophets. The nave's fifteenth-century carved oak ceiling has a multitude of carved, figures including animals, birds and angels. The church was re-floored in Victorian times with richly coloured floor tiles, and the carved font is early medieval.

In February 1739, Robert Cadman (or Kidman), a steeplejack by trade, came back to Shrewsbury, accompanied by his wife, to repair the damaged weathercock. Although Cadman was a local man, he worked all over the country and, in order to supplement his meagre income, he also performed as a professional rope-slider and showman; he was known as 'Icarus of the rope'. At the time, Shrewsbury was celebrating the Great Frost and holding a fair on the River Severn, often called the

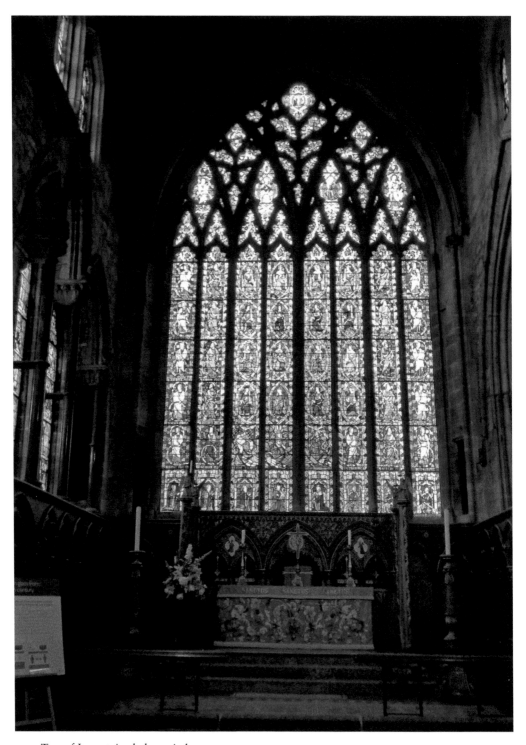

Tree of Jesse stained-glass window.

Fifteenth-century carved oak
ceiling.

Sabrina when it was frozen, after Hafren, the Welsh Goddess of the River Severn,
whose Latin name is Sabrina).

In order to publicise his next daring feat, which involved sliding down a rope
that would be attached at one end from the 222-foot-high spire of the church,
across to the other side of the river, where it was anchored in Gaye Meadow
below – Cadman had already had a handbill circulated advertising the proposed
flight, which was scheduled to take place on Monday 2 February 1739. When
the great day arrived, he made his way up the 800 feet of rope to the top of the
spire. On the way, with a great crowd watching from below, he fired pistols
and performed several tricks before reaching the very top of the spire. When he
reached the top, he secured the grooved wooden breastplate to his leather doublet
and prepared to 'fly' down, headfirst, to the anchor point in Gaye Meadow. Before
he launched himself, however, he noticed that the slide rope was too tight and
required some adjustments. He gave a signal to slacken the rope, but his order
was misunderstood and, instead of the rope being slackened, it was tightened.
As he was passing over St Mary's friars, the rope snapped and Cadman went
plummeting into the crowd below. Whilst he had been performing, his wife had
been mingling amongst the crowds and passing around the hat. Upon witnessing

the developing disaster, she 'threw away her money in an agony of grief and ran to him', although nothing could be done to save him. Cadman was buried in the church grounds, and there is a plaque recording the tragedy on the wall to the right of the main entrance.

Location: SY1 1DX

St James' Church, Stirchley

There is still evidence of its Norman origins in the church of St James, Stirchley; this includes the chancel at the east end of the church, which is the oldest part of the church and is built of stone, probably dating from the mid-twelfth century. In all probability, the construction work would have been financed by Osbert of Stirchley, who was the first recorded Lord of the Manor, having held the position of undertenant from 1167 to 1180. The eighteenth-century nave and west tower are made of brick, and the tower has a round-headed west doorway with a window situated above. In the upper-bell stage there are small round-headed bell openings. The tower has a pyramidal roof with a finial and weathervane. Many of

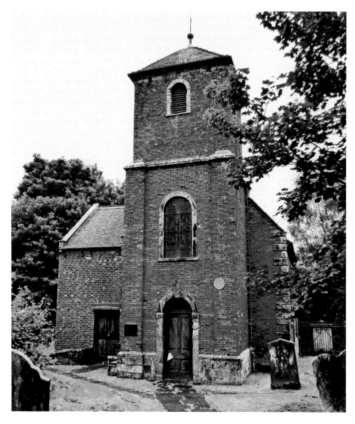

St James' Church, Stirchley.

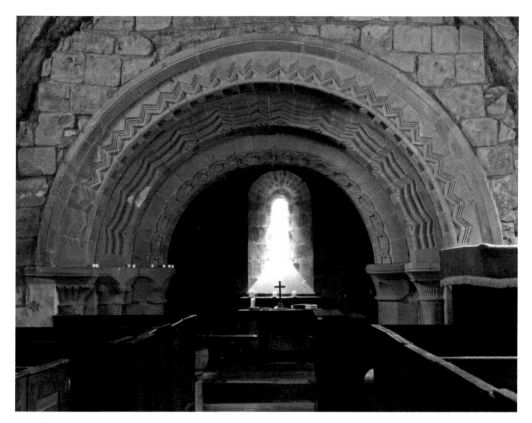

Twelfth-century Norman chancel arch.

the church's interior furnishings date from the Georgian period, featuring several box pews, a west gallery, and a carved pulpit.

St James, Stirchley, is built in a simple neoclassical style, with a west tower and simple nave. The first known rector was Walter, who had the title of Chaplain of Stirchley. He was the priest at St James' from 1220 to 1230. Relating to the founding of the church at Stirchley, Rev Robert Eyton commented that 'This was in its original state a chapel, probably in the Parish of Idsall (Shifnal), and founded by the Manorial Lords of Stirchley in the twelfth century'.

Apart from some minor structural changes during the fourteenth century, when an Early English window was inserted in the south wall of the chancel, no other structural changes took place until 1740. It was during the incumbency of William Banks, who was Rector of St James for upwards of forty years, that the stone-built nave was encased and remodelled in red brick, adorned with dressings of sandstone in the contemporary neoclassical style. A new roof and a flat-plaster ceiling were also incorporated sometime during the same decade.

It was the Clowes family of Stirchley Hall who were Lords of the Manor at that time. Thomas Clowes, the last member of that family, had no successors, and it is thought that it was he who financed the expensive alterations to the church. The church-going tradition at the time gave prominence to preaching and

the reading of the Bible, rather than focusing on the ritual of the Mass. Thomas Clowes, as sponsor of the rebuilding programme, had his place reserved at the most prestigious seat in the church: a large pew directly in front of the pulpit. There is much speculation as to why the stone-faced chancel was not also encased in brick, one of the more popular beliefs being that there were just not enough resources left to complete the job.

Originally, there were two east windows but, early in the nineteenth century, these were replaced by one larger window. In 1838, three local ironmasters – brothers Thomas, William, and Beriah Botfield, owners of the local Old Park Ironworks – commissioned the construction of a north aisle, which also incorporated a gallery for their workmen. The gallery extended into the nave and provided additional seating for 120 people. The brothers also had built a vault underneath the floor of the north transept, but this was exclusively reserved for the use of members of the Botfield family. A notice on the front reads:

> This transept and gallery were erected by Thomas, William and Beriah Botfield at their sole expense for the accommodation of their workmen and poor in this and the adjoining parish. Also, the vault under this transept was built for their own use. Anno Domini, 1838.

Towards the end of the incumbency of Hugo Moreton Phillips as rector, the ceiling of the nave, which had become unsafe, was removed in 1877. The church did, however, retain the high box pews and the two-decker pulpit, which was contrary to popular fashion in nineteenth-century English churches.

Appointed Rector of Stirchley in 1894 for the next fifteen years, the Rev William Hunt Painter made it his business to restore the fabric of the church and rectory. Following his death on 12 October 1910, a tablet was erected by his parishioners and friends in affectionate remembrance of his faithful and untiring labours for the good of his church and people. Further structural enhancements were made to the church during Rev H Penkivil's incumbency. In 1919, the front of the gallery was set back into the north aisle in an attempt to render it less obtrusive.

There is a ring of three bells at St James' Church, Stirchley. The treble bell, the first bell, was cast in 1410 at the foundry of John de Colsale near to Nottingham, at the time when Rev William Spark was the rector of the parish. The second bell was cast in 1664 by the bell founder Thomas Clibury II while Rev George Arden Junior was the rector. The third bell, the tenor, was cast by Henry Oldfield II of Nottingham in 1594 when Robert Bell was the rector.

For many years, the three bells at St James' were unusable, but then, in 2007, the bells were restored by the bell founders and bell hangers Matthew Higby & Co. of Bath. The bells were re-hung with new traditional-style fittings in the existing timber bell frame, and the old bells were removed and reinstalled through a hole in the tower roof. Contrary to usual practice, the bells form an anti-clockwise ring.

When the church of St Laurence, Burwarton, closed for worship in 1972, the Victorian and Edwardian stained glass, which had probably been installed by Clayton & Bell of London, was installed in St James'.

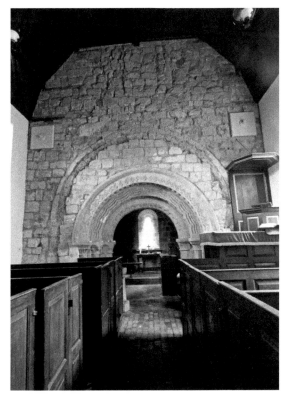

Above left: The box pews fitted during the 1741 refurbishment.

Above right: Small octagonal font near to the chancel arch.

In 1979, the church, having become redundant as a place of worship, was restored by the Telford Development Corporation and now functions as a museum. At the time of the restoration, when plaster was being removed from the east wall of the nave, some small areas of late medieval wall painting were exposed.

Location: **TF3 1DY**

ST ALKMUND'S, WHITCHURCH

Dedicated to Alkmund of Derby, the first church, a Saxon church at Whitchurch, is thought to have been founded in or around 912 by Ethelflaeda, daughter of Alfred the Great, although the earliest records of a church being on the site only date from 1089. Following the Norman Conquest, a new, white Triassic Grinshill sandstone church was built. It is believed that the town's name is derived from the translation of 'white church'.

The first rector was installed in 1296. Another church was built in 1350, but disaster hit the church on 31 July 1711 when the central tower, which dated from

fifteenth century, collapsed. The collapse was attributed to either the sheer weight of the tower or possibly unsatisfactory foundations. This tragedy necessitated the entire church having to be rebuilt. There is a wooden plaque to left of south-west door bearing a painted inscription that testifies to the disaster, and it also states that on 27 March 1712, the foundation stone was laid and that the new church was consecrated on 8 October 1713.

The church was designed by John Barker of Rowsley and built by master mason William Smith of Tettenhall. It follows the neoclassical style of architecture and is mainly built with red sandstone ashlar and has a slate roof. In plan, the church has a six-bay nave with north and south aisles. There is a three-bay apsidal chancel, a south porch and an integral west tower. The tower itself has four distinct stages: the first stage has a tall, round-arched small-paned window on the west side; the second stage has a number of oculi windows; a carved stone coat of arms is displayed on the south side of the third stage, with paired round-arched niches on the other sides; then, on the north and south sides of the fourth stage are clock faces dating from 1977. The tower contains a peal of eight bells, with the founders Rudhall of Gloucester casting the first seven. Five bells were cast in 1714 and the other two some years later in 1767. The eighth bell was cast by John Taylor & Co. of Loughborough in 1842. The mechanism of the church clock was manufactured by the local company of J. B. Joyce & Co. – established in 1690 and claimed to be the oldest clock manufacturer in the world. Then, rather unusually, the tower is surmounted by a balustrade with large urn corner finials. The church needed some restoration work, which was carried out between 1877 and 1879, with further work being completed between 1885 and 1886. The organ, by Conacher and Co. of Huddersfield, was overhauled, rebuilt as a three-manual pipe organ and moved to the north of the chancel in 1894. The organ was refurbished in 1966 by the Norfolk-based pipe organ manufacturers, Hill, Norman & Beard. There was more re-modelling at the beginning of the twentieth century, when the internal walls were re-faced and the porch rebuilt. In 1972, the north and south galleries were removed.

There is an arcade of Tuscan columns and round arches that divide the aisles from the nave.

The gallery at the west end is supported by a pair of unfluted wooden Doric columns. The Lady Chapel, which is entered through an oak screen, is at the east end of the south aisle. There is a Jacobean communion table with a nineteenth-century marble top in the chapel, alongside a sandstone reredos that has carved panels and several painted inscriptions. There is also, above the reredos, a painting of the Last Supper, which is attributed to the Italian Renaissance painter Bonifazio Veronese. The body of John Talbot, 1st Earl of Shrewsbury, who had been killed at the Battle of Castillon in 1453, was removed to the church towards the end of the fifteenth century. His bones lie under his effigy in the Lady Chapel, and his embalmed heart was buried under the porch. The tomb was restored in 1874 by Adelaide Countess Brownlow, daughter of the 18th Earl of Shrewsbury. The chest tomb of Revd Sir John Talbot, a descendent of the 1st Earl of Shrewsbury, is at the east end of the north aisle in the north wall. He was the founder of Whitchurch Grammar School. The red and yellow sandstone font under the gallery dates from 1661.

The font's wooden cover was made from the sounding board of an earlier eighteenth-century pulpit. The Ten Commandments are written on two boards across the north aisle wall, and the carved wooden eagle lectern dates from the nineteenth century. There is an inscribed sundial on the wall just above and to the left of the porch. The sundial has a wrought-iron gnomon. Nineteenth-century stained glass has replaced much of the original clear glass in the tall, round-arched windows. The design and installation of the stained-glass window in the apse is credited to the Gothic Revivalist William Warrington. The window, dating from

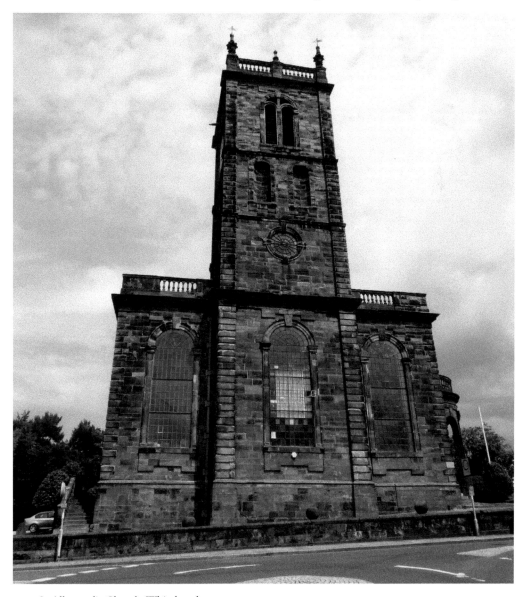

St Alkmund's Church, Whitchurch.

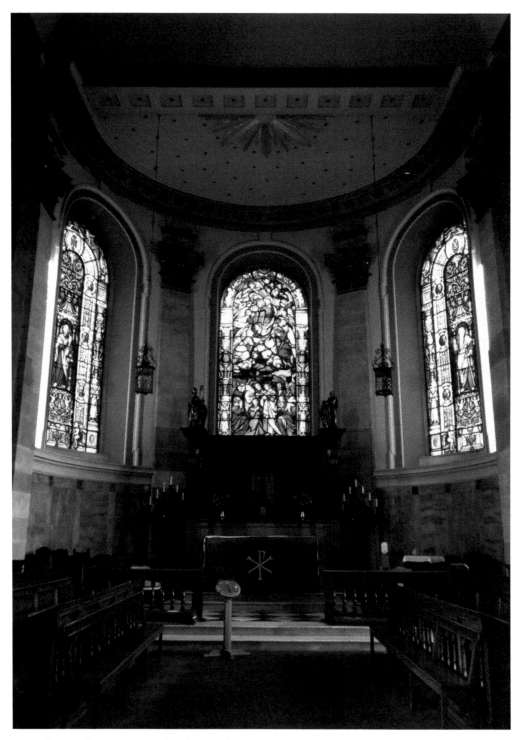

Chancel of St Alkmund's Church, Whitchurch.

Above: Six-bay nave.

Right: The nineteenth-century carved wooden eagle lectern.

1860, depicts the Ascension of Jesus. There are images of Saint Peter and Saint Paul on either side. It was manufactured by the London stained-glass company of Ward and Hughes.

In the churchyard there is a sundial, the war grave of a Royal Field Artillery soldier from the First World War and a chest tomb dedicated to the memory of Ann Loveit.

Location: **SY13 1LB**

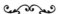

St Mary the Virgin, Bromfield

The founding of this church can be traced back as far as the reign of Edward the Confessor. Once described as 'a wealthy minster of royal foundation', the parish church of St Mary the Virgin at Bromfield was built before the Norman Conquest. The priory at Bromfield was also in existence before this time and was served by twelve canons. After Henry II had granted it a charter as a Benedictine priory in 1155, both the canons and monks became part of the establishment, with the priory and the parish church becoming more integrated.

Church of St Mary the Virgin, Bromfield.

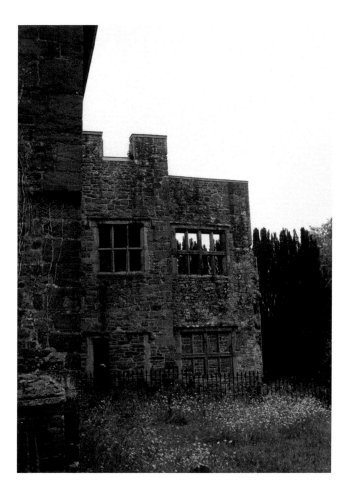

Blocked mullioned windows –
the derelict remains of Foxe's
original conversion.

The church was rebuilt to a traditional cruciform plan sometime during the twelfth century, although the current north-west tower was added during the thirteenth century. This re-building became necessary after the collapse of the original central tower at the crossing. It is thought that the overall weight of the original tower, together with the church's proximity to the river, that subsequently led to tower's collapse. During that time, the monks of the priory had the use of both the crossing and the south transept for their services, whilst the western part of the church was used by the laity.

In plan, St Mary's has a north aisle, chancel, nave and north-west tower. There is a porch in the lowest of the three stages of the tower, together with a north doorway and a lancet window above. The tower parapet is embattled.

In 1558, following the Dissolution of the Monasteries in 1541, the church and priory were leased and later sold to Charles Foxe, second son of Ludlow MP William Foxe. Part of the church was then converted into a residential property, and the nave, north aisle and north porch continued to function as the parish church. Inserted into the blocked, round-headed Norman arch at the east end of the church is a three-light Perpendicular window, above which, in the

gable, is a blocked mullion window, which is all that remains from Foxe's original conversion.

After a disastrous fire in the house during the seventeenth century, the family left the dwelling and, in 1658, the building itself was restored in its entirety to a place of worship. In 1672, the chancel was re-painted, with the total cost of refurbishment being met by Richard Herbert of Oakly Park. During the same year, the plaster ceiling of the chancel was painted by Thomas Francis of Aston-by-Sutton. The scene painted depicted the Shield of the Trinity surrounded by cherubs and texts, and angels holding the Bible open at Psalm 85. Below the decorated chancel ceiling, there is a Netherlandish-style reredos triptych, painted by the artist Charles Edgar Buckeridge. The central panel depicts the Crucifixion, with the side panels representing 'the glorious company of the apostles'.

St Mary the Virgin has a ring of six bells, five of which were cast in 1737 by Abel Rudhall. The sixth bell and a Sanctus bell were cast in 1890 by John Taylor & Company. A north vestry was added when the ecclesiastical architect Charles Hodgson Fowler oversaw further restoration work, which was carried out between 1889 and 1890. New windows were also added on the south side at this time.

In 1890, the original two-manual pipe organ, which had been built and installed in 1866 by the organ builders Joseph William Walker & Sons Ltd, was enlarged and re-constructed by the company. They also overhauled the organ in 1991.

The reredos triptych painted by Charles Edgar Buckeridge.

The Shield of the Trinity ceiling, painted by Thomas Francis.

Much of the stained glass, including the glass in the north aisle and west window, dates from the late nineteenth to the early twentieth century, and was made by the Victorian stained-glass designer and manufacturer Charles Eamer Kempe.

There are three war graves in the churchyard, the first being that of a soldier of the King's Shropshire Light Infantry who died in the First World War. The other two war graves are those of two Welsh Guardsmen who lost their lives in the Second World War.

Location: **SY8 2JP**

ST JAMES', CARDINGTON

The Domesday Book records the village of Cardington as Cardintine under the Fief of Rainwald Vicecomes. The village is credited as having eleven leagues of woodland.

In 1167, William FitzAlan, Lord of Oswestry, gave the village to the Knights Templar of Jerusalem. The village then became known as Templars' Cardington and remained in their possession until 1308. Although there is no evidence of an earlier church on the site, it is thought that the present church, which has elements of Norman, Early English and Gothic architecture, was first built by the Knights Templar sometime towards the end of the twelfth century. In 1185, Arnolf was vicar of the parish, and it is considered that the elevated position of the church at Cardington is due to the site once being an ancient henge.

The plan of the church is typical of the Norman period, having a short rectangular nave and, originally, a low west tower. The second half of the twelfth century saw the building of the eastern part of the nave, which was then extended at the end of the century with the addition of new north and south doorways. Sometime in the thirteenth century, the chancel was extended. There is both a

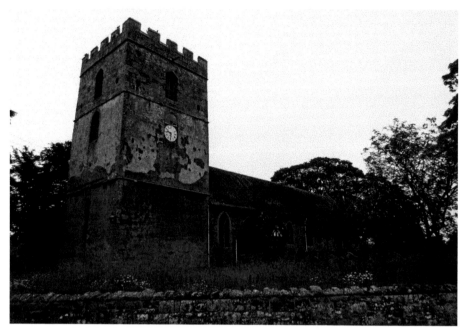

St James' Church, Cardington.

View looking towards the chancel's east window.

single- and two-light window on the side walls of the chancel, with a restored lancet window set in the east wall. The nave had a number of windows added during the fourteenth century, two on the south side and one on the north side. Also, during the latter part of the fifteenth century and the early part of the sixteenth century, the upper stages and battlements of the tower were added and capped with a pyramid and weathervane.

The firm of James Powell and Sons made and installed the east window in 1914: a memorial to Captain Stephen Christy, who was killed in 1914 at the end of the First World War, and Violet Christie, his wife, who died in 1913. The stained-glass window in the nave is by the Arts and Crafts designer Edward Payne and was installed in 1955. The family-run business of George Sixsmith & Son Ltd built the two-manual pipe organ in 1985, which was dedicated on 29 April 1986.

There are five carved panels on the Jacobean pulpit, resembling what have been described as either mermen or, more probably, fishermen. In the centre-front of the

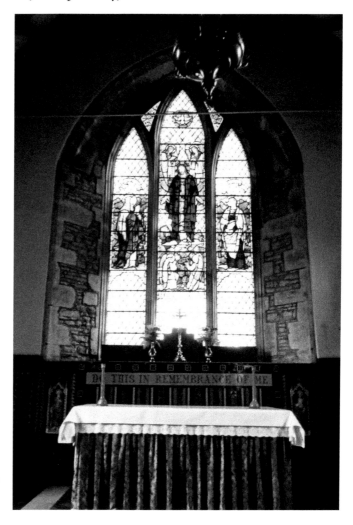

East window, installed in memory of Captain Stephen Christy, who was killed during the First World War.

altar, there is a carved panel depicting the Crucifixion. It is thought that the panel originally adorned the pulpit, and in the centre of the glazed tiles, which are on the wall behind the altar, are the words 'Do This in Remembrance of Me'. The Saints, who are also depicted on the tiles are Saint James (on the right) next to Saint Peter, who is holding the keys to the kingdom. The other two saints, both holding books, are Saint Andrew and Saint John.

Many of the Elizabethan pews have now been refurbished, some bearing carved initials of members of the congregation. In 1868, the church's Norman tub-font was replaced by the present font; this gesture was in honour of Revd William Jones Hughes M.A., who had been the vicar of the parish for forty years until his death in 1865. Following the installation of the new tower clock, the pendulum was started at precisely twelve noon on Easter Monday, 21 April 1889 by Mr E Sayer of Plaish Hall. An account of the service of dedication of the clock and the subsequent celebrations in the schoolroom was reported in the local press.

Sundial dating from the eighteenth century.

There is a memorial on the north wall of the nave dedicated to Roger Maunsell. Also, there are two brasses in the chancel: the one on the north wall is dedicated to the memory of Thomas Norris, and the one on the opposite wall is dedicated to the memory of Ann Tipton. Judge Leighton's tomb is in the church, although both he and Judge Jeffreys were known as 'Hanging Judges', a reference to the number of people both had condemned to be hanged.

St James' Church has a ring of eight bells, the first bells being cast in 1626 by William and Thomas Clibury, followed by a bell that was cast by Abel Rudhall in 1752. There are, however, some records that would suggest there was a ring of three bells in the church as early as 1553. Following some re-casting in 1887 by James Barwell, a ring of four bells was established, and this configuration remained until 1981, when the ring was restored by John Taylor and Company, newly installed in the clock room in a new iron frame. Prior to this, the original medieval timber A-frame in the bell tower had beds for three bells, which were rung from the vestry floor. There were further changes in 1985, when a new ringing gallery incorporating the organ platform was built in the vestry space. Also, during that time, a new pipe organ was installed. Two trebles were added by John Taylor in 1990, making a ring of six. The bells were dedicated on 1 November 1990, All Saints Day. In 2005, a former bell ringer at the church, Kath Cooke, left a legacy to the church, which enabled two more trebles to be added, making a ring of eight bells. The Bishop of Hereford dedicated the bells on 5 February 2006.

Standing on two circular stone steps in the churchyard to the south of the church there is a sandstone sundial that dates from the middle of the eighteenth century. Also, in the churchyard, there is a group of five late-eighteenth and early nineteenth-century chest tombs. There is also a pedestal tomb to the memory of Richard Butler, which is dated 1831. The fact that the churchyard has five wooden gates around its perimeter is significant to the pastoral role that Saint James followed in his ministry. The wedding gate, which is near to the war memorial, and the funeral gate are two of the most prominent gates.

The church porch was built in 1639 and features numerous initials carved on a small wooden shield above the gates.

Location: **SY6 7JZ**

St Michael and All Angels, Loppington

Reference is made to Loppington in the Domesday Book, although the village's name is spelt 'Lopitone'. The main body of St Michael and All Angels Church dates from the fourteenth century, although there was an earlier Norman church on the same site, traces of which can still be seen. The west tower and the south aisle date from the fifteenth century, and the tower is in three stages. The embattled parapet has gargoyles at three corners that enclose a pyramidal roof with an ornamental brass weathercock.

The church has a chancel, south aisle, nave, porch and west tower. The short, one-bay chancel has a fifteenth-century window on the south, which is similar

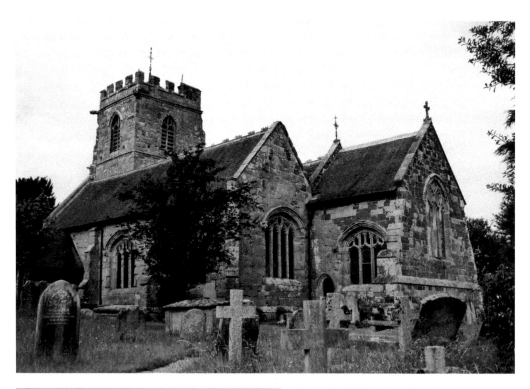

Above: St Michael and All Angels Church, Loppington.

Left: Looking towards the chancel and east window.

Seventeenth-century oak chest.

to those in the aisle. There is also a narrow doorway with a two-centred arch to west. There is a large, disused medieval basin font near to the nineteenth-century octagonal font, which is currently still in use. The church also has an eighteenth-century panelled pulpit, with more panelling being re-used in the nineteenth-century pews and the organ gallery. In front of the north door there is a seventeenth-century oak chest and a nineteenth-century board, which records the benefactions of Mary Griffiths of Woodgate to the parish.

In 1643, during the Civil War, Parliamentarian troops were garrisoned in the church. The roof and south porch were burned, and other damage was inflicted when Royalist troops stormed the building. As a result, the church needed to be partially rebuilt; the refurbishments included the building of a new south porch, which was added in 1658.

More restoration work became necessary in the early eighteenth century, and further renovations were made under the direction of J. L. Randal between 1869 and 1870. St Michael's has a peal of three bells. The tenor and second bells were cast by William Clibury of Wellington, the former in 1605 and the latter in 1624. The treble was cast by John Rudhall of Gloucester in 1787. In 1935, Gillett & Johnston of Croydon re-tuned and re-hung the bells with new fittings, in a new steel frame.

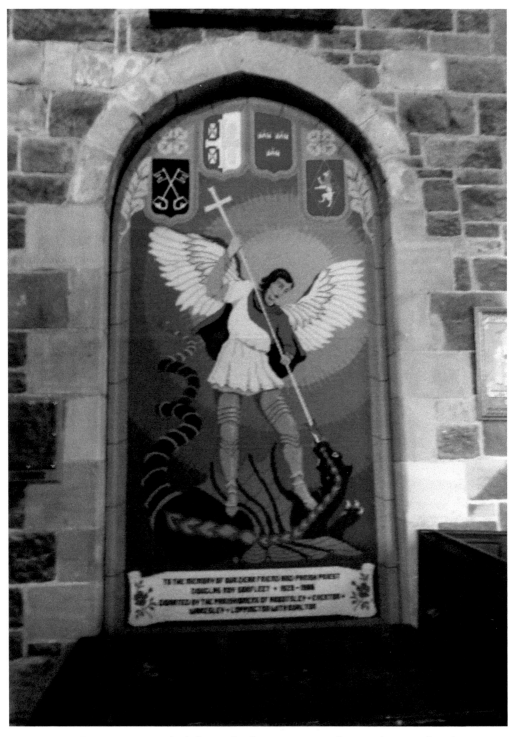

Tapestry depicting Saint Michael slaying the dragon, a memorial to Revd Roy Sorfleet, former vicar of the parish.

The Noneley hatchments above the south door.

The 3-foot-high sundial in the churchyard dates to 1695. The original plate, which is kept in the church, has a decorated gnomon and dial, depicting two twelve-hour number series in Roman numerals. The plate is inscribed 'Arthur Hatchet and Roger Kynaston, Church Wardens 1695'.

Location: **SY4 5SR**

ST PETER'S, WROCKWARDINE

Wrockwardine was recorded in the Domesday Book as 'Recordine', meaning 'homestead' or 'enclosure by the Wrekin'. Roger de Montgomery, the 1st Earl of Shrewsbury, was tenant-in-chief of Wrockwardine at the time of the Domesday survey, and it is thought that he gifted the church at Wrockwardine to Shrewsbury Abbey. According to this most famous survey, there was a priest living in the manor of Wrockwardine at that time. It is likely that this would have been Odelerius of Orleans, who was Rector of Wrockwardine Church from 1066 until 1095.

The church was an integral part of the abbey church until 1540, and the patronage of the vicarage also belonged there; after that time, it passed to the Crown. Following several exchanges, the patronage passed to R. C. Herbert, whose great-grandson, V. M. E. Holt, owned it until 1981. From that time, the living was united with a number of other parishes, and the patronage was jointly held.

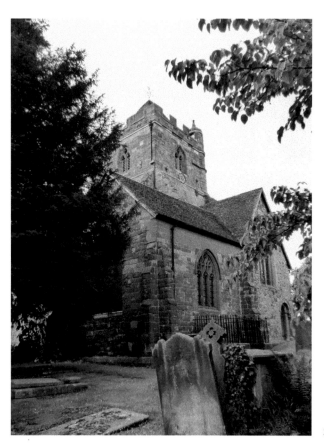

St Peter's Church, Wrockwardine.

Although Saxon in origin, it is believed that the current church building dates from the Norman period, with later modifications. The church was rebuilt towards the end of the twelfth century in a cruciform plan, with the tower and stair turret at the crossing, rather than at either the east or west end of the building. The tower was to be supported on four pointed arches and the upper storey was to be lit by four pointed windows. Three round-headed east windows, together with north and south windows, lit the chancel. The Cludde Chapel in the north transept was added towards the end of the fourteenth century. Originally, the early church had centrally located north and south doorways, with the south doorway being used as the main entrance until 1854.

In order to allow for the insertion of a two-light window, sometime in the fourteenth century, the nave was extended five metres to the west. Also, during the fourteenth century, the Cludde Chapel was constructed to have openings from the chancel and north transept. It is also possible that the chapel may have replaced an earlier one, with the arch into the transept dating from the thirteenth century. The three twelfth-century windows in the chancel were replaced by an east window.

Later on, possibly in the late fifteenth or early sixteenth century, the south chapel was built, access to the chancel and transept being gained through half-arches. However, in 1751, the then Vicar of Atcham sold the chapel to Edward Pemberton;

Above left: South-side priest's door.

Above right: Sundial in churchyard.

the chapel then became known as the Pemberton Chapel. Joshua Gilpin served in the parish from 1782 until 1828, and during that time multiple restoration programmes were proposed and completed, the first being in 1808, when John Carline made his report on the fabric. Subsequently, Samuel Pountney Smith of Madeley was asked to estimate the cost of repairs and building works to include the erection of a new gallery. A south gallery was built by 1838, followed by a north gallery in 1854, the work for which was carried out by Richard Dodson. During that same year, Ewan Christian made some radical proposals regarding alterations and repairs, some of which were rejected. However, many of his proposals were adopted, including the blocking of the south door and the opening of a west one; the insertion of north and south windows in the western part of the nave; the blocking of the south chapel's east door and the chapel being converted into a vestry; the removal of the north gallery; replacing the pews with benches; the nave being partially re-roofed; and the chancel being re-floored. The pulpit was also rebuilt, and new communion rails were installed.

Towards the latter part of the eighteenth century and the early part of the nineteenth century, the choir, consisting of up to sixteen treble singers, was augmented with a parish orchestra, which included violins, viola, bass viol and clarinet. It is recorded that in 1843, during the incumbency of G. L. Yate (1828–73), the galleries had 63 free seats and 110 children's seats. Even so, in 1884, seat holders voted to retain all 56 rented places.

In the early part of the twentieth century, under the guidance of the incumbent A. A. Turreff (1906–1945), there was a marked change in the church's activities: the number of Sunday services was increased from three to four, and there was now a monthly communion – there were often there as many as 200 communicants at Easter services.

In the Cludde Chapel, there is an ancient parish chest dating from the fourteenth century. It was used to store charity money and had three separate locks and keys. Even after so long, all the locks are still in working order. There is also an oak chancel screen and a Jacobean oak pulpit inside the church.

A font, dating from the twelfth century, was given to the church in 1934. Additionally, the church has a portable font and two other fonts dating from the nineteenth century. The sundial in the churchyard dates from 1750. Of the four fonts, the oldest dates from Norman times and, for reasons of security, is kept at the old St Chad's Church. One of the fonts – the font used at the present time – was presented to the church in memory of Revd A. P. Salusbury, who was vicar from 1874 to 1896.

The communion rails date from 1865, but were only returned to St Peter's in 1931, having been found in Wrockwardine Hall. Working to the designs of T. L. Moore, further refurbishments were carried out between 1906 and 1907, when the north chapel was restored and the tower and chancel underpinned.

There are four commemorative windows, namely located at the west end of the south wall, the east end of the south wall, and within the north wall. The windows are dedicated to the memory of Richard and Elizabeth Emery, Miss E. Leake, who died serving in the First World War and Lt Col W. Oldham, who died serving in the Second World War. The fourth commemorative window can be found in the north wall, east end, and was designed and installed by Mary Jane Newill in memory of her parents. During the nineteenth century, one of the original Norman windows in the chancel was replaced by a stained-glass window depicting Holman Hunt's painting *The Light of the World*.

St Peter's has a peal of six bells, four of which date from 1549, with a fifth being added in 1686. The sixth bell was added in 1828, and the fifth bell was dismounted in 1951 and replaced by a new bell.

Location: **TF6 5DZ**

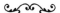

St Peter's, Edgmond

When the Norman Earl of Arundel and Shrewsbury, Roger de Montgomery, was granted Shropshire from William the Conqueror in 1071, he committed himself to building a monastery. On 25 February 1083, he summoned his senior officials, including Warin the Sheriff of Shropshire and Robert de Say, and publicly pledged himself to establish a new Benedictine abbey. He then laid his gloves on the altar of this small Saxon chapel dedicated to Saint Peter and granted the whole suburb outside the east gate for the construction. The Domesday Book later recorded:

'In the city of Shrewsbury Earl Roger is building an Abbey and has given to it the monastery of St Peter where the parish church of the city was.'

The church building, which predominantly follows the Perpendicular style of architecture, save for the fourteenth-century chancel, which favours the Decorated style, includes a nave (with north and south aisles), an embattled south porch, a chancel, and a three-stage west tower with a peal of eight bells. The embattled tower has crocketed corner pinnacles, and there is an eighteenth-century painted sundial on the wall of the south porch, with a stone statue of two children directly above the entrance door. There is an unusual tub-shaped early Norman font with decorated cable and guilloche interlacing near to the west end of the church. Another interesting feature is the stone reredos dating from 1899: the carved figures on the reredos are the work of the Bodley and Garner partnership and depict scenes from the Crucifixion.

The church was enlarged during the thirteenth century and then almost completely rebuilt during the following two centuries, with the chancel being almost the same length as the nave. During a major restoration between 1877 and 1878, the architect George Edmund Street had the side walls of the church reduced in height in order to incorporate a steeply pitched roof to the chancel.

On entering the church there is a holy water stoup with a damaged bowl, which is said to have been caused by locally garrisoned roundhead troops. In 1937, Rushworth and Dreaper added pneumatic action to the original 1860's two-manual Nicholson and Lord pipe organ. Further modifications were made by P. D. Collins towards the end of the twentieth century, when the pneumatic action was replaced with mechanical action. There is a peal of eight bells at St Peters; the original four bells were cast in 1721 by Abraham Rudhall II of Gloucester. Then, between 1887 and 1977, a further four bells were added, all being cast by John Taylor and Co. of Loughborough.

The church has many outstanding examples of stained-glass windows, created by some of the country's leading designers. A window attributed to Morris & Co. can be seen in the south wall of the chancel; the window depicts the Virgin Mary and Mary Magdalene, although some historians suggest that the window is a depiction of the sisters Mary and Martha. The millennium window in the north wall of the nave was dedicated during the Clypping service of 4 July 2004 by the Ven. John Barrie Hall, Archdeacon of Salop, and reminds us that 'Nothing can separate us from the Love of God'. On the south wall of the nave, there are stained-glass windows by James Powell & Sons and Clayton & Bell. Dating from 1891 and depicting the Annunciation, the work of the Victorian designer Charles Eamer Kempe can be seen in the east window above the reredos in the sanctuary.

The church community still celebrates the ancient tradition of Clypping, a ceremony that usually takes place on the first Sunday following Saint Peter's Day. The word 'Clypping' is derived from the Anglo-Saxon word 'clyppan', which means to embrace or clasp. At the end of the service, members of the congregation leave the church and, clasping hands and facing outwards from the church, form an unbroken circle around the building. The hymn 'We love Thy Place O' God' is then sung. The tradition was revived by the rector of the parish Revd Charles Piggott in 1867, incumbent from 1865 to 1888. The west window, made by Hardman & Co, was gifted to the church by Eliza Winham following the death of Revd Charles Piggott. Saint Francis and the wonders of creation are depicted in

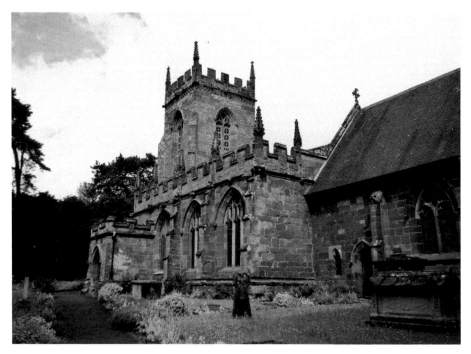

St Peter's Church, Edgmond.

Stone statue of two children directly above the entrance door.

Above left: Wall-mounted sundial.

Above right: Looking from the nave towards the chancel.

Right: The tub-shaped early Norman font.

the window. A number of memorials in the churchyard commemorate the Piggott family, who were rectors of the church from 1699 to 1886.

Location: **TF10 8JY**

St Chad's, Shrewsbury

The parish of St Chad has been established in Shrewsbury since Saxon times. Tradition suggests that the church was founded by King Offa after his conquest of Pengwern, thus dating its establishment to the last quarter of the eighth century.

The old St Chad's was said to have been 'spacious and cruciform'. Most of the building was said to have been erected during the thirteenth century, and the two-stage tower had a peal of ten bells.

At the time of the Domesday survey, St Chad's was a collegiate church, the private property of the Bishop of Lichfield. Before the Norman Conquest, the church had sixteen canons. Then, in 1075, following the transfer of the Holy See from Lichfield to Chester, the college was re-founded, with a staff consisting of a dean and ten canons. Early sketches of the medieval church indicate that it was a large church, built to a cruciform plan in the Early English style, with a central tower over the crossing and a Lady Chapel in the angle of the chancel and south transept.

As with other churches in Shrewsbury, two types of stone were used in the building of the medieval St Chad's, indicating that construction occurred at two distinctly different periods of time. Red Keele Beds sandstone was used for the chancel and nave, a material preferred in the twelfth and thirteenth centuries, whereas the Lady Chapel, aisles and tower were built from Grinshill sandstone, a material used in the later medieval period.

There was a serious fire in 1393 when a plumber who was making repairs to the roof, by negligence, set fire to the building. The building was badly damaged, and, in an attempt to escape from the consequences of his carelessness, the culprit fled the town. Unfortunately, he was drowned in the River Severn near to the ford of the Stone Bridge. As a result of the fire, extensive work was needed on the chancel, nave and tower roofs.

In 1788, cracks started to appear in one of the four pillars that supported the central tower. The County Surveyor of Public Works, Thomas Telford, was asked to inspect the church's fabric. He reported that a number of graves were too close to the tower's shallow foundations. This, coupled with decaying roof timbers, had left the structure in a weakened and dangerous state. Telford recommended that the tower, together with its ring of bells, be taken down to allow for remedial work to be carried out. His plans were rejected on the grounds of excessive and unnecessary expenditure. Instead, a stonemason was employed to cut away the cracked sections and underpin the pillar. Then, on the evening of 8 July, just two days after work had commenced, the bells were rung for a funeral. The ringing caused the tower to shake so violently that the sexton was forced to evacuate the building. Disaster came the following morning when, as four o'clock was striking, half of the tower collapsed, taking the roof and large sections of the church with it.

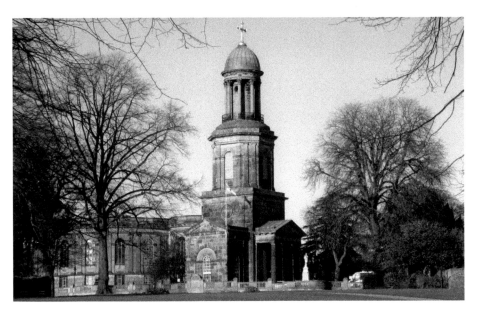

St Chad's Church, Shrewsbury.

An act of parliament was passed shortly after, which enabled money to be raised to erect a new church. George Steuart, a leading Scottish architect, was commissioned to design the new church. When the plans had been completed, Steuart sent them to the trustees for approval, placing a circle on his plans that denoted the proposed site for the new church. Unfortunately, this reference was misunderstood by the trustees who, unwittingly, agreed to the construction of a circular building, rather than the design favoured by the Parish Church Council. The foundation stone for the new church was laid on the feast day of Saint Chad, 2 March 1790. Some of the masonry from the old church was used to build the foundations, and the church was consecrated on 19 August 1792, having cost nearly £20,000. The first marriage in the new church took place on 22 August 1792.

The works supervisor during the building of the church was John Simpson, who went on to work closely with Thomas Telford on several important projects. There is a memorial to him on one side of the sanctuary arch, with a similar memorial on the other side to William Hazledine, a pioneering ironmaster whose foundry in Shrewsbury manufactured the slender cast-iron pillars upon which the gallery is supported.

The original three-decker pulpit was removed in 1888 and replaced by the choir and clergy stalls. A copper and brass pulpit fashioned in the Arts and Crafts style has been erected at the entrance to the sacrarium. The church has a three-manual pipe organ, which was built and installed by the Norwich-based organ manufacturers Norman & Beard in 1904. The organ is housed in the gallery that was erected in the eighteenth century over the west entrance. Above that is a figure of Saint Chad, which remains as one of the few relics of the old church and can be seen in the vestry of the new St Chad's. The organ was later restored by Nicholsons in 1963 and, in 1985, by Harrison & Harrison of Durham. Further renovation was completed by Harrison & Harrison at a cost of £300,000 in 2011. The Dean of Lichfield rededicated the restored organ on 20 November 2011.

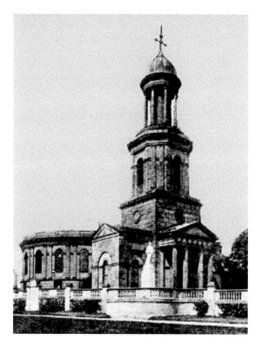

Early image of St Chad's, Shrewsbury.

The original bells were cast in 1798, shortly after the new church had been built. They were re-cast in 1914 by John Taylor & Co. and still hang in the original eighteenth-century wooden bell frame. St Chad's now has a ring of fourteen bells, a further two bells having been added to celebrate the millennium.

The east window is copied from the painting by Rubens, which is in the south transept of Antwerp Cathedral. There is a depiction of *The Descent from the Cross*, and the two side openings are copied from the same work, representing the Visitation and the Presentation of Jesus at the Temple. The window was made in the 1840s by a local stained-glass artist David Evans.

St Aidan's Chapel is on the right-hand side of the main entrance to the church. After the Second World War, it was made into a memorial chapel for the local regiment: the 53rd Regiment of Foot and its successor regiment, the King's Shropshire Light Infantry (KSLI). Memorials include: an alabaster tablet to officers and men of the 53rd who died on 10 February 1846 at the Battle of Sobraon; a tablet to the men who died in the Indian Mutiny Campaign, 1857–1859; a tablet to those of the 1st Battalion KSLI who died in the Egyptian Campaign of 1882; a tablet to those of the 1st KSLI who died in the occupation of Suakim, Sudan, 1885–1886; a tablet above the vestibule entrance commemorating all of the 4,700 KSLI men who died during the First World War – the memorial was unveiled in 1930 in presence of Poet Laureate John Masefield. There are also, in separate cases, books of remembrance for all KSLI men who died in both World Wars.

Other monuments include a Jacobean memorial in black and white marble with Corinthian side columns dedicated to Thomas Edwards and his wife; a wall tablet with Ionic side columns in memory of Richard Taylor, who died in 1741; and a red mottled-marble memorial to Richard Hollings.

The remains of Revd John Yardley, Vicar of St Chad's for almost sixty years, were buried here in 1888. This was the last interment in the chapel. As a memorial to a former vicar, Revd Richard Eden St Aubyn Arkwright, one of the vestries was enlarged and converted into a chapel in 1914. On 15 November 1809. Charles Darwin, the evolutionary scientist, was baptised in St Chad's Church.

Location: **SY1 1JX**

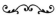

St Andrew's, Shifnal

Documentary evidence testifies that there was a settlement in Shifnal dating from the early Anglo-Saxon period, and the name of the town itself is thought to be an amalgam of two separate parts: the first part being taken from a personal name, 'Scuffa', and the second part is presumably derived from 'halh', meaning valley – obviously describing the topography of the village. The village is recorded in the Domesday Book as being in the hundred of Alnodestreu, although it was once known as 'Idsall', a name of possible Roman origins.

The parish church of St Andrew's, Shifnal was originally a minster church. At that time, there was a chapter of priests serving the area. Thought to have been built on the site of an earlier Saxon church, St Andrew's has a Norman chancel together with an Elizabethan double-hammerbeam roof. The church, being a collegiate church, and having a chapter of priests, had an obligation to minister to the needs of congregations in outlying settlements. However, St Andrew's relinquished its collegiate status when it was given to Shrewsbury Abbey in 1087.

It was built in the twelfth and thirteenth century, with some modifications during the fourteenth and fifteenth centuries. On 7 July 1591, fire swept through the town, burning down most of the buildings to the east of Wesley Brook and setting alight the roof of the church. However, the church, together with Old Idsall House, were the only two buildings to survive the blaze. It is thought that the fire started when the flame from a maidservant's candle accidentally caught some hanging flax. Queen Elizabeth I later sent money to help rebuild the town. Following the fire, roof repairs were carried out at the church.

St Andrew's is cruciform in plan, having a central tower, a south chapel, a vestry to the north, a four-bay chancel, a four-bay nave, and aisles with a south porch. The three-stage tower has setbacks, a stair turret to the north-west, a battlemented parapet and a pyramidal roof with finial. There is a seventeenth-century wooden pulpit and a nineteenth-century octagonal stone font. The large three-light west window in the nave was inserted sometime between 1848 and 1852. The east window was designed and manufactured by John Hardman Trading Co. Ltd in 1867, and the two windows in the south transept are by James Powell and Sons (Whitefriars Glass).

Major restoration work was carried out between 1876 and 1879 under the direction of Sir George Gilbert Scott. Then, between 1899 and 1900, the architect William Douglas Caröe was commissioned to add a north vestry. There are several monuments to members of the Brigges family in St Andrew's Church, including

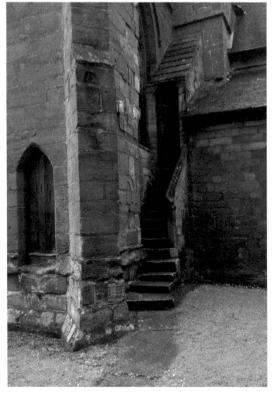

Above: St Andrew's Church, Shifnal.

Left: Entrance to the bell tower.

a tomb chest in the south chapel with a recumbent effigy of Oliver Brigges. There is another tomb chest in the south chapel with two recumbent effigies of Humphrey Brigges and his wife. There are also two small kneeling figures situated at the feet of Humphrey's wife. There is a tablet in south chapel commemorating Revd Moreton, with another tablet in the chapel in memory of Mary Bagott. A tablet on the south chancel wall commemorates Magdalen Brigges, and in the north chancel wall there is a tomb recess for Thomas Forster.

St Andrew's also has a wall memorial dedicated to the memory of Mary Yates. Mary was known locally as Nanny Murphy and, it is believed, as a young teenager, just after the Great Fire of London in 1666, she walked all the way to London. In her later life, Mary married her third husband at the age of ninety and died at the age of 127. To the north of Shifnal there is a Nanny Murphy's Lane. The wall memorial is also dedicated to the memory of William Wakely, who was baptised in St Andrew's on 1 May 1590 and was buried on 28 November 1714. Wakely lived through the reigns of eight kings and queens.

Thirteen soldiers of the First World War and four of the Second World War, who are all buried in the churchyard, are commemorated on a screen wall memorial in the church. Of the eight bells in the peal, seven were cast in 1770 by Pack and Chapman

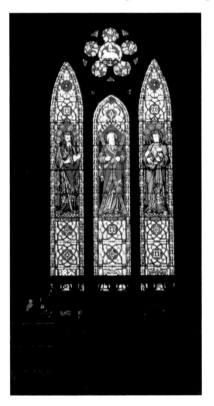

Above left: Three-light west window.

Above right: Nineteenth-century octagonal font.

of London, with the fourth bell being cast by the same founders the following year. The bells hang from wooden headstocks in their original wooden frame.

Location: **TF11 9AB**

St John the Baptist, Kinlet

Even before the time of the Domesday survey, Kinlet was a village of some significance featuring a wooden church sometime before the Normans erected a stone building as a place of worship. The name Kinlet is taken from the word 'kin', meaning 'royal', and 'lett', alluding to district, and dates from the time when the knoll was held by Queen Edith of Wessex, the widow of Edward the Confessor.

In the fourteenth century, Kinlet passed by marriage from the Bromptons to a branch of the Earls of Cornwall. Then, towards the end of the fifteenth century, the Blount family became the owners of the estate.

The church of St John the Baptist, Kinlet, probably stands on the site of a former wooden church, which was built sometime before the Norman Conquest. The architecture would suggest that there were two principal periods of construction: Norman Transition, dating from the end of the twelfth century and the beginning of the thirteenth century; and the Decorated period, dating from the beginning of the fourteenth century. Norman architecture is evident in the aisle arcades, as it has typical round arches supported by circular piers.

The first Vicar of Kinlet is recorded as being William Philipp, who was presented by the Abbot and Convent of Wigmore in 1288. The church plan includes a chancel with transepts projecting from both the north and south walls, a south porch, a nave with narrow aisles, and a tower at the western end. The church was reconstructed during the thirteenth century, when the western tower was added, and the Norman arch was replaced by a finely moulded one. The porch was added during this period of reconstruction, as was the upper section of the tower. The chancel, which measures 40 feet by 21 feet, becomes wider towards the eastern end. The east window has five lights of interlacing tracery and a circle at the top, and the figures depicted in the glass include Saint John the Divine, a knight with the Cornish Arms, and a female saint with a palm branch and a bird.

The narrow central stage of the three-stage tower is pierced by two lancets to the north and west. The bell stage is an early Perpendicular addition, and the tower is embattled and has corner pinnacles. The four original bells at Kinlet date from 1549, with two other bells being added in 1553 and 1740, although the present bells were re-cast at the Whitechapel Bell Foundry in 1857. There is also a Sanctus bell at Kinlet.

There are two alabaster tomb chests in the chancel, one in the north and one in the south. The tomb in the south of the chancel has effigies of Sir Humphrey Blount and his wife Elizabeth Winnington Blount. Sir Humphrey's will stipulated that his body was to be buried in St Catharine's Chapel, Kinlet. The altar tomb in the north of the chancel has a carved effigy of Sir Humphrey's grandson Sir John Blount and his wife Katherine Peshall, shown wearing a wimple, together with their eleven children, five sons and six daughters.

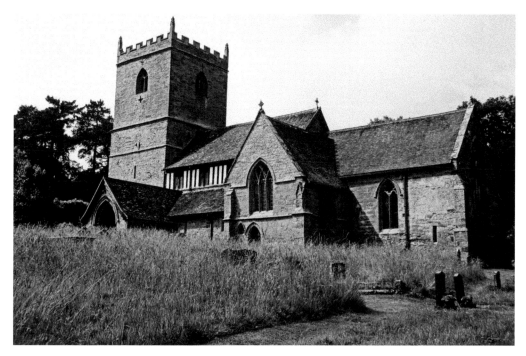

Parish church of St John the Baptist, Kinlet.

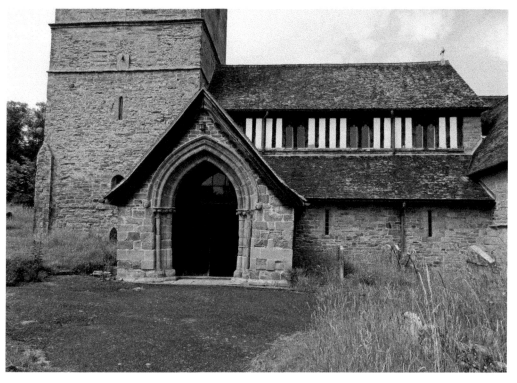

South entrance porch at Kinlet.

Churchyard cross, restored and
rededicated, August 1921.

Backed up against the north wall in the north transept is a monument, dated
1581, commemorating Sir George Blount of Kinlet. The carved monument shows
Sir George standing apart from his wife, Constantia Talbot, and their children.
In the south-east corner of the chapel there is an effigy of a woman with a child
wrapped in her mantle. The woman is thought to be Isobel Cornwall, who died in
childbirth sometime in the early fifteenth century.

The carved alabaster reredos, having the Good Shepherd as its central figure,
was installed in 1901 as a memorial to the memory of Major Charles Baldwyn
Childe, who was killed at Spion Kop.

Between 1892 and 1894, there were some significant additions to the church
made under the direction of the English architect John Oldrid Scott: oak screens,
carved in Sweden, were introduced; a vestry was added on the north-west side; the
church was re-seated; and the clerestory was renovated. Many of the monuments
were also moved from the chapels and repositioned. The churchyard cross at
Kinlet is quite remarkable and dates from the late thirteenth century.

Location: **DY12 3BL**

ST MARY'S, STOTTESDON

Both Norman and Early English styles of architecture are evident in the structure
of St Mary's Church, suggesting that the church dates from the period between
1060 and 1270. Much of the structure is post-Norman, although there is some

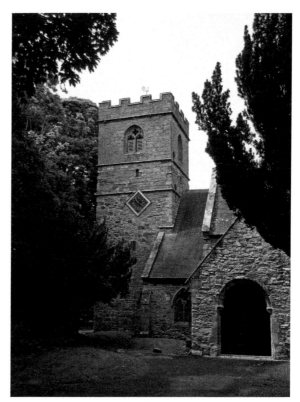

Right: St Mary's Church, Stottesdon.

Below: Light streaming though the east window.

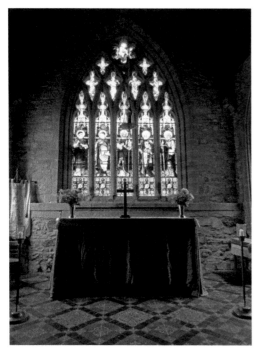

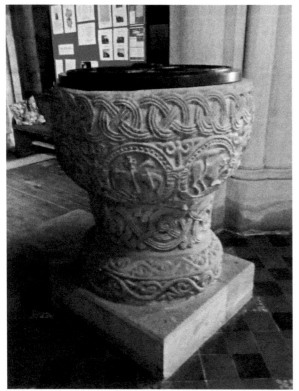

Above left: Five-light east window, similar to the east window at Kinlet.

Above right: Jacobean pulpit.

Left: The Norman font, thought to be the work of the Herefordshire School of Romanesque Carving.

evidence of pre-Norman building. The first written record of the church is recorded in the Domesday Book, and it was built by Robert de Bellême, 3rd Earl of Shrewsbury, and he later presented it to Shrewsbury Abbey.

The church has an aisled nave with a south porch, a chancel and a west tower. The tower and aisles date from the twelfth century, but there is evidence of Saxon masonry within the west wall of the nave. The unbuttressed tower rises in three stages to the battlements, and the central stage is very narrow and has two-light bell openings, following early Perpendicular architectural lines.

The earliest architectural feature of the church is the carved hunting scene, which can be seen on the tympanum above the Saxon west door. There are also fragments of medieval glass in the small south window. The large carved stone Norman font, which dates from 1138, is the work of the Herefordshire School of Romanesque Carving, which was active during the reign of King Stephen. A magnificently carved Jacobean wooden pulpit was added around 1620.

St Mary's has a ring of four bells which were re-cast in 1752 by Abel Rudhall of Gloucester. The turret clock, which dates from 1855, was manufactured by J. B. Joyce & Co. of Whitchurch.

Restoration work became necessary during the nineteenth century and was directed by the architect Thomas Blashill. The Arts and Crafts rood screen was added to the chancel arch in 1901. In the churchyard there are war graves of three British soldiers who died during the First World War.

Location: **DY14 8UE**

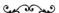

St Giles', Barrow

St Giles' Church, Barrow, was founded on the estate of one of the country's earliest monasteries, Wenlock Abbey – later to be known as Wenlock Priory – and is one of the oldest churches in Shropshire. Originally built as a chapel to the abbey, the chapel was used as an oratory for solitary prayer. St Giles' has the only surviving Anglo-Saxon chancel in the county. However, there is some uncertainty as to the date of the building of the chancel, with estimates varying from the eighth century up until the eleventh century. Wenlock Priory presented the first recorded incumbent, John de Wicumbe, to the parish in 1277, although he was not in holy orders. Wenlock Priory retained the patronage of the chaplaincy until 1540, after which time officiating ministers were appointed by the Vicar of Much Wenlock.

There is an Anglo-Saxon window on the north wall of the chancel and a Norman priest's doorway in the south wall. There are also Norman features in the nave, including a window and a doorway in the south wall and two windows in the north wall. The tower has a Norman window and a Norman west doorway. The neoclassical porch has been built in red brick with rusticated stone quoins.

The church has a west tower, nave, north chapel, south porch and chancel, with the chancel being built as early as the eleventh century. The oldest parts of the building are the chancel and chancel arch, although the Normans later built a priest's door

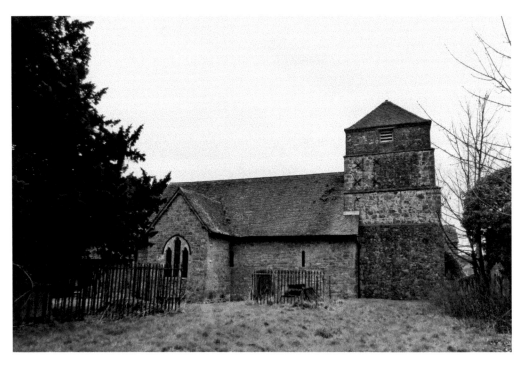

Above: St Giles' Church, Barrow.

Left: Norman priest's doorway in the
south wall.

in the same place. The lower stages of the tower were built in Norman times, but the final stage of the tower, together with its pyramidal roof, was added during the eighteenth century, when a new entrance, together with a new south porch, was built.

There is an original Norman window in the south wall of the nave and another two in the north wall. However, the oldest window in the church is in the chancel. The Norman nave, which probably replaced an earlier timber nave, dates from the early twelfth century. Barrow Chapel remained a dependency of Holy Trinity, Much Wenlock, until the early seventeenth century. The north transept was built in 1688 by Samuel Bowdler of Arlescott.

Richard Knott, the so-called 'intruding' minister, came to the parish in 1642. Originally, he stayed until the time of the Restoration of the Monarchy in 1660, but then departed the parish, returning two years later and then staying as incumbent for a further fifteen years.

In 1705, the south porch was rebuilt in brick with the addition of an iron gate. Then, between 1851 and 1852, the church was restored under the direction of the English church architect George Edmund Street. Following that restoration work, between 1894 and 1895 Ewan Christian was commissioned to rebuild the

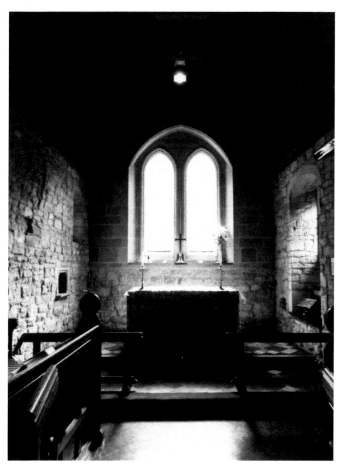

Anglo-Saxon chancel.

porch and the east wall of the chancel. At the beginning of the nineteenth century, it was suggested that a further two pews should be added to the one that Edward Ruckley had built in the chancel; however, this action was resisted when the patron, George Forester, threatened to pull down the chancel were that to happen.

The plain tub font dates from the twelfth century, and the drum-shaped timber pulpit is decorated with traceried panels. St Giles has a poor box dating from 1690 and a number of wall monuments that date from the seventeenth, eighteenth and nineteenth centuries.

Early in the sixteenth century a young boy fell into St Mildburga's Well in Much Wenlock. Many different actions were taken in order to revive him, one being a barefoot pilgrimage made by his father and monks from Wenlock to Barrow. Religious observance was closely adhered to. At the beginning of the seventeenth century, there were four celebrations of communion every year, with a sermon being preached every Sunday. Then, during the 1670s, that number was increased to five times and year and then, from the 1690s, communion was celebrated up to six times every year.

One of two of St Giles' bells dates from 1661. Included in the church's plate, there is a chalice dating from 1625 and a paten that dates from 1700. The churchyard, which was closed in 1882, has a number of cast-iron memorials. Following the closure, Lord Forester donated some land to allow for a new cemetery to be consecrated near to the original graveyard. One grave of note is that of Tom Moody. Tom was the whipper-in at nearby Willey Hall in the eighteenth century. Tom, very much a character in his own right, was well-known in the area, not only for his undoubted skills as a horseman, but also for his macabre fear of being buried alive. When sensing that his time was near, Tom asked his master, Lord Forester, to grant him one last request, and that was to check and see if he was just sleeping before he was laid six feet under. His specific wishes were laid down as follows:

> When I am dead, I wish to be buried at Barrow under the Yew trees, in the churchyard there. And to be carried to the grave by six earth stoppers and my old horse, with my whip, boots, spurs and cap slung on each side of the saddle. And the brush of the last fox when I was up at the death at the side of the forelock, and two couples of old hounds to follow me to the grave as mourners. When I am laid in the grave, let three halloos be given over to me and then, if I don't lift my head, you may fairly conclude that Tom Moody is dead.

Tom's wishes were duly carried out before he was laid to rest. The church cemetery contains the neoclassical chest tomb of John Rose, who was for many years the creator of the Coalport China Works. He died in 1841. Thomas Turner is also buried here; he played a significant role in expanding those same works. There is also a war grave of a Royal Artillery soldier who died during the First World War. In 1976, the United Benefice of Linley with Willey and Barrow was created.

Location: **TF12 5BW**

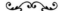

ALL SAINTS, BERRINGTON

Reference is first made of the church and a priest at Berrington in the Domesday Book, although there is speculation that the site itself was used as a place of worship way before Christian times. There is a Norman font assigned to the church, but the nave follows the Early English style and was built during the thirteenth century. The carvings on the font are quite significant: the candle signifying Christ being the light of the world, while the cockerel recalls the denial of Christ by his apostle Peter. The beast which is carved into the font is thought to be a lion, the context of which is referenced in the First Epistle of Peter, chapter 5, verse 8, which reads:

> Be sober, be vigilant; because your adversary the devil, as a roaring lion, walketh about, seeking whom he may devour.

During the rebuild in the thirteenth century, two sculptures were added high up in the corners at the west end of the nave. In the north-west corner, there is a figure wearing a frilled cape, and to the south-west there is a devil with a stick in its right hand. The symbolism relates to a superstition that decrees when spilling salt, it should always be thrown over the left shoulder and into the face of the devil.

Sometime towards the end of the thirteenth century, a wooden sculpture of a knight in prayer was gifted to All Saints Church. The figure is known locally as Berrington's Knight, or Old Scriven, although the knight's real identity has since been lost. Legend declares that the knight fought a lion and, for his troubles,

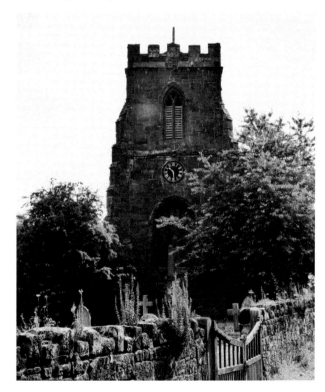

All Saints Church, Berrington.

Berrington's Knight.

received damage to his face. The sculpture is located beneath an arched recess in the south wall of the Lady Chapel. There is the distinct possibility that the knight was possibly a member of the one-time patrons of All Saints, the Lee family of Langley. As it was the Lee family that funded the alterations that were made to the church during the fourteenth century, it is reasonable to assume that they might also have commissioned a statue to commemorate one of their fallen brethren.

The chancel was added at a somewhat later period – the Decorated period – as was the new aisle on the south side of the nave. Sometime towards the end of the fifteenth century or the beginning of the sixteenth century, the Perpendicular-style, two-stage embattled tower was added. There are many grotesque heads around the string course at the top of the first stage.

There is a monument to Adah Greaves to the right of the altar. Adah, who died in 1638, was the wife of the then rector, Samuel Greaves. The monument depicts Mrs Greaves kneeling between two composite columns, with an inscription that conveys her 'piety, zeal, modesty and abundant grace'. Close by, there is an early-Georgian monument to the memory of William Franke. Franke died in 1736 and was married to the co-heiress of the Eaton Mascott estate. To the left of the altar, there are monuments to members of the Williams family, owners of Eaton Mascott. The monument to Richard Williams is by the Shrewsbury sculptor John Carline, whereas the monument to his son, Arthur Charles Williams, is by T. Daniel. There is a monument by the younger John Bacon to Rebekah Gillian Williams who died in 1827.

Sometime during the 1820s, the then church warden, John Aston, commissioned David Evans of Shrewsbury to design and insert the stained glass in the east window. There are three figures represented in the window: on the left there is a depiction of Saint John the Evangelist, in the centre is Saint John the Baptist and on the right-hand side is Saint Peter. The Aston Arms are depicted above. The chancel's north stained-glass window, commissioned by John Hardman Trading Co., was inserted in 1876 in memory of Thomas Wells, who, at the time, lived at Eaton Mascott. Memorial gifts to the church included an intricately carved reader's chair

and a lectern, both by the Italian artist Rinaldo Barbetti. The pulpit was made and gifted to the church by Edward Hughes of Shrewsbury. However, modifications had to be made to the church floor before the large pulpit could be accommodated.

In 1877, Edward Haycock of Shrewsbury was commissioned to carry out a number of structural changes to All Saints. At that time, the church was re-pewed after a new tile floor had been laid. New windows were inserted in the north and south sides, and the original stone roof slates were replaced with manufactured tiles. The north door arch was moved so that access could be gained through the south porch.

In 1913, a two-manual pipe organ made by Blackett & Howden was given to the memory of James Cavan, a tenant at Eaton Mascott Hall. All Saints has a peal of eight bells. Originally, in 1552, the church had a peal of four bells together with a Sanctus bell, but the present peal is from a much later date. The bell founder Thomas Mears I, at the Whitechapel Bell Foundry, cast six of the bells in 1796. In 1926, the same foundry restored and re-hung the bells as a mark of respect and as a memorial to Gilbert Culcheth Holcroft, the eldest son of Sir George Harry Holcroft of Eaton Mascott Hall, who was killed in action during the First World War, and his wife, Lady Annie Gertrude Holcroft. In 1948, Mears and Stainbank, also of the Whitechapel Bell Foundry, cast another two bells for All Saints.

The tower's clock, first recorded in 1680, was renewed in 1888. The sundial in the south churchyard was supplied by Carlines of Shrewsbury in 1814. The dial was crafted by a local man, Richard Harper.

Standing in the older churchyard is the parish's war memorial to the locals who lost their lives during the First and Second World Wars. The memorial, sculpted by Landucci and Sons, is in the form of an obelisk. One of the names listed is that of Pilot Officer Montague Hulton-Harrop, who was shot down during a friendly fire incident known as the Battle of Barking Creek. There are several more monuments in the churchyard, including the chest tomb of Benjamin Bromley, which dates from 1779, and two chest tombs of members of the Meire family, dating from the latter end of the eighteenth century. The Leake Memorial can also to be found in the graveyard.

Location: **SY5 6HB**

ST EATA'S, ATCHAM

Atcham is an abbreviation of Attingham, which means the 'home of the children of Eata'. Eata was Abbot of Melrose, and later of Lindisfarne, sometime during the seventh century. Eata was a close friend of Saint Cuthbert, and it is believed that a church sat on this site from as early as the eighth century, but the earliest reference to there being a church at Atcham can be found in *The Ecclesiastical History of Ordericus Vitalis*, where the writer declares that he was baptized on the Easter Saturday in the year 1075. Ordericus, the priest, officiated at the service, and he was also one of the godfathers. The service was held at Ettingesham (now known as Attingham) in the church of Saint Eata the Confessor. The parish church of St Eata, Atcham, is the only church in England to be dedicated to Eata of Hexham. Eata was

Bishop of Hexham from 678 until 681, then Bishop of Lindisfarne from 681 until 685. He then returned to Hexham where it is thought he died of dysentery in 686.

The church was built in Norman times, sometime during the twelfth century, although it is thought that it was built on the site of the original church. At one point the church fell under the jurisdiction of the monks of Lilleshall Abbey, who had the right of levying a tax at the Atcham passage.

In plan, there is a nave with south porch, a chancel and a western tower. The chancel itself dates from the latter half of the thirteenth century, although the doorway and windows follow the late Early English style of architecture. There is a twelfth-century Norman window in the north wall of the nave. The south

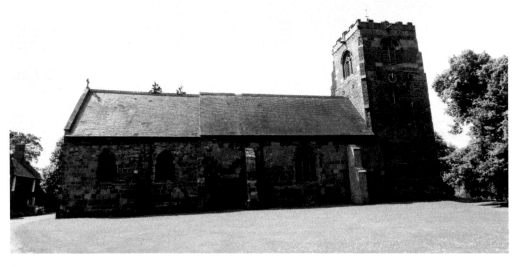

Above: St Eata's, Atcham.

Left: Indentations in the wall, where arrows were once sharpened.

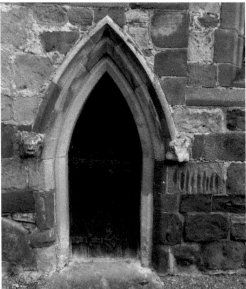

porch was built in 1685. The tower, which is in four stages, dates from the twelfth century and is in the style of late Transitional architecture, but the upper stage follows the Perpendicular school. The bottom stage has a round-arched west doorway, and there is a large lancet window on the west side of the second stage, with paired lancet windows in the third stage. There is a quatrefoil frieze at the top of the tower, together with corner gargoyles, a parapet with truncated pinnacles, and a small pyramidal cap. The nave is the oldest part of the present church and dates from the late Saxon or the early Norman period. There is a small round-headed window in the north wall of the nave, with the other windows in the nave being Perpendicular in style. The chancel dates from the late thirteenth century.

In 1528, Richard Coton, who was vicar at the time, preached a sermon at Atcham for which he was sentenced by Bishop Blythe 'to carry a faggot in procession around Lichfield Cathedral and afterwards around Atcham church'. Coton was thought to have had Lollard leanings.

In 1553, when William Cuerton was the incumbent and Thomas Maddoxe and Robert Cotewall were the church wardens, the church's goods return on 6 May stated that there was at Attingham a silver chalice and paten, together with four bells and a Sanctus bell. The church at Atcham is thought to have been used as a blockhouse during the Civil War in order to protect the nearby waterway of the Severn. This assertion is evidenced by the marks remaining both internally and externally as a result of cannon ball fire, and the indentations in the wall to the right of the doorway where arrows were once sharpened.

There are many memorials to both the Burton and Noel-Hill families, and to the Calcotts of Berwick Maviston and the Joneses of Chilton Grove. There is an incised slab to Edward Burton and his wife and seven daughters, placed near to the pulpit. There is a brass dedicated to the memory of Robert Lyster of Duncot and his wife, Anne. There are tablets to Samuel Jones, a vicar, who died in 1725, and to Samuel Fowler, who was minister for 46 years, alongside Ann, his relict. There is stained glass in both the east and north windows, which was brought

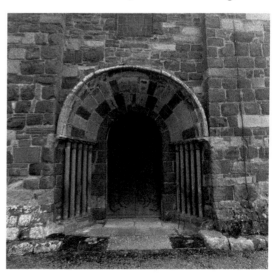

Norman arch and east-end entrance.

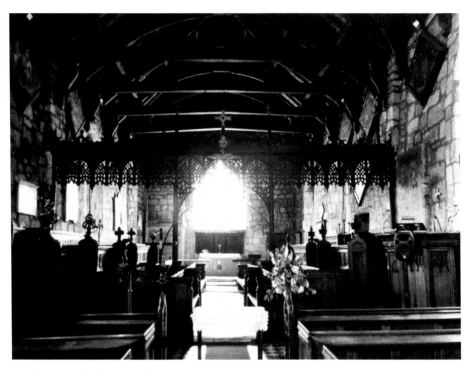

Looking towards the chancel.

from Bacton Church in 1811 by Mrs Henry Burton. The windows are dedicated to Blanche Parry, who died in 1589.

One of the relics remaining at St Eata's Church is a reading desk that was carved, it is thought, by the German painter Albrecht Dürer, with panels portraying scenes taken from the Parable of the Prodigal Son. The font can be dated to 1675 and bears the initials of the former church wardens.

St Eata's has a ring of six bells. Four bells were cast by Abraham Rudhall I at Gloucester in 1709, and the third and fourth were cast in 1829 by Thomas Mears II at the Whitechapel Bell Foundry. In 1879, a lightning strike caused a serious fire in the ringing gallery, inflicting injury on several children. Due to the damage to the fabric and the injuries to the children, the gallery was taken down in 1896. Soundweld, the bell repair specialists of Newmarket, repaired the cracked tenor bell in 2005. The bells were then re-tuned and re-hung by John Taylor and Co. of Loughborough. In 2014, a new bell-ringing gallery was installed.

There are five Commonwealth war graves in the churchyard that, combined, commemorate two British airmen, a Canadian airman, an Australian airman and an airman from New Zealand, all of whom died in the Second World War. Also buried in the churchyard is Anna Bonus Kingsford, a feminist writer and wife of the then Vicar of Atcham.

Location: **SY5 6QE**

ACKNOWLEDGEMENTS

I would wish to record my thanks to the many people who have assisted me in collecting and collating information with regard to the historic churches recorded in this text. I especially wish to thank my wife, Janet, for accompanying me when taking photographs of the various churches mentioned in the text, and to my son, Jon, who read and made a number of useful corrections to the manuscript.

Finally, whilst I have tried to ensure that the information in the text is factually correct, any errors or inaccuracies are mine alone.

ABOUT THE AUTHOR

David Paul was born and brought up in Liverpool. Before entering the teaching profession, David served as an apprentice marine engineer with the Pacific Steam Navigation Company.

Since retiring, David has written a number of books on different aspects of the history of Derbyshire, Cheshire, Lancashire, Yorkshire, Shropshire and Liverpool.

ALSO BY DAVID PAUL

Eyam: Plague Village
Anfield Voices
Historic Streets of Liverpool
Illustrated Tales of Cheshire
Illustrated Tales of Yorkshire
Illustrated Tales of Shropshire
Illustrated Tales of Lancashire
Illustrated Tales of Derbyshire
Speke to Me
Around Speke Through Time
Speke – History Tour
Historic Churches of Derbyshire
Woolton Through Time
Woolton – History Tour